A LANDSCAPE OF WALES

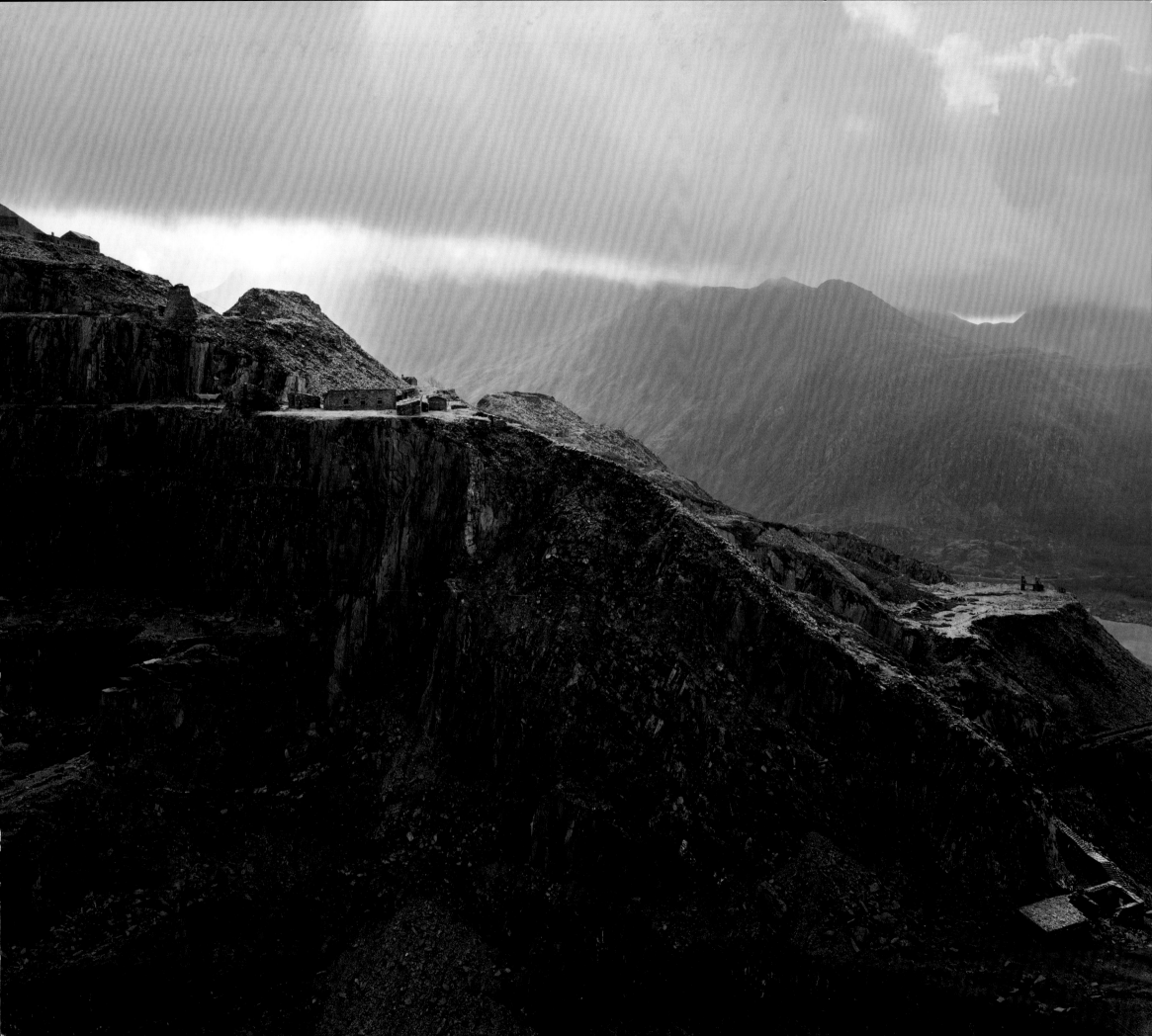

A LANDSCAPE OF WALES

James Morris

introduced by Jim Perrin

dewi lewis publishing

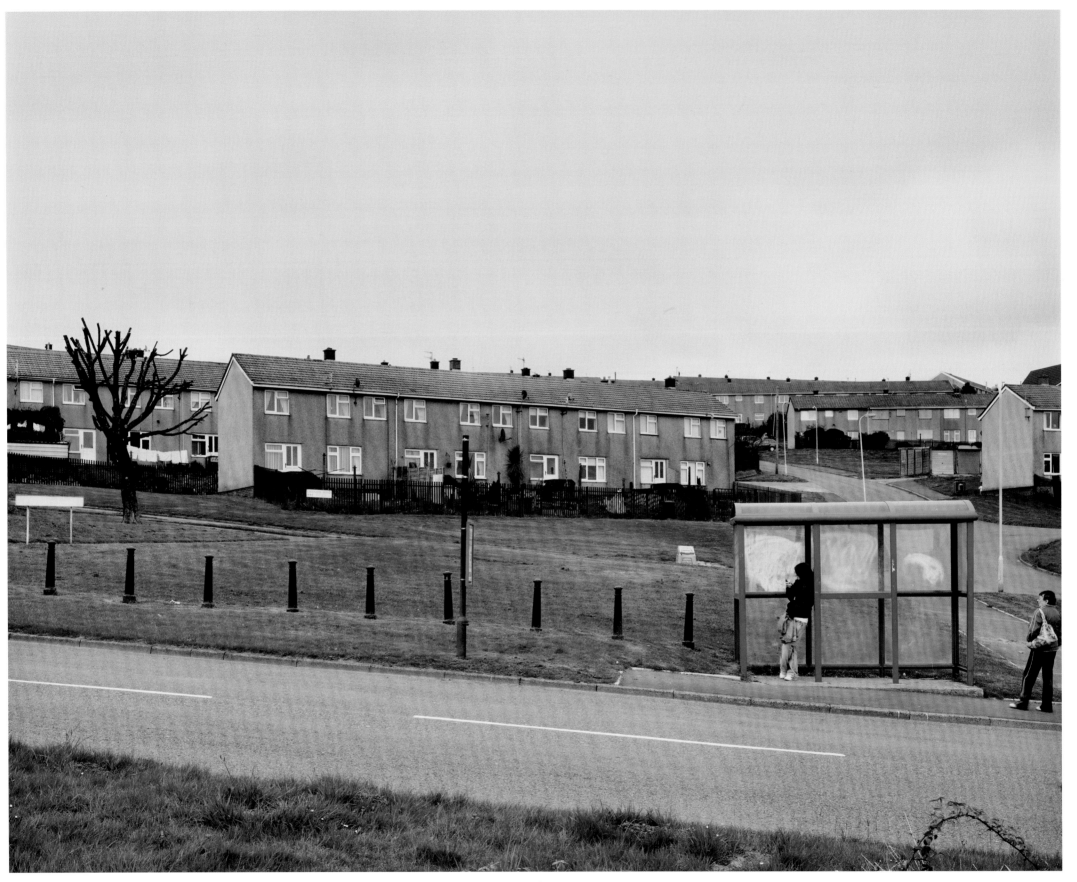

Lavender Road, Gurnos, Merthyr Tydfil

SHADOWLESS LIGHT JIM PERRIN

The donkey-foal behind the fence of faded-orange electrified tape on my daily walk is learning how to bray…

There is more:

A year ago on uncertain purple hooves, suckling at his dark mother – now the cross on his back, the lips curled, and a squeaky wheeze comes out…

There is more:

Bullfinches softly descant from the ash-tree beneath which the foal stands, orange lichen mottled across its bark. Behind the woodyard at the bottom of the field rows of evenly spaced poplars…

There is more:

Their topmost silver branches form overlapping feather-budded vee's, that scumble or obscure a faint mauve flush creeping through oakwoods still winter-sombre behind…

There is more:

Gleam of snow rims the Crete de Madoual. Last autumn I peered over and saw a *sanglier*, a wild boar. An encounter. Our eyes met…

Always there is more:

In the spring that will come soon here to the Pyrenees, white blossom of the wild cherries is scattered, conspicuous throughout the woods.

Hold now – here is the point at which my words will begin to fail me.

Eye and mind together are radiant in their attention, their perceived images ever on the point of dissipation. The picture thus becomes unruly, and escapes. Thoughts of spring and the wild cherry in this far and imagined place cut me loose from the dispassionate or even the real, engender their peculiar blind compulsions, pitch me headlong into romanticism, association – into a flux of shifting registers and of synaesthetic confusions scarcely controllable however aware I might remain of them. Writer's tongue and ear are not so cool as surgeon's gaze or photographer's lens, concentration of both of which are fixed and singular. My jazzy impulse, my adherence to shifting witness of the eye, wishes to play fugues around James Morris's images. Would perhaps thus travesty the strange knowledge that emerges from his stilled and chosen moments? Of which we are avoidant:

Chosen moments or meditative texts? If you have not seen the Wales that is the subject of these photographs, then what obstacles of preconception have you put in the way? For this is how it is. This is Wales. In one man's vision, momentarised and selective,

untainted by an idealising, a rhetorical, a sentimental, a proselytising imagination.

A bus shelter in the Gurnos, by Merthyr; bollards, railings, an alien listless palm. White sheets dry beyond a black, pollarded tree. Long-haired girl slouches against the shelter, tiny screen of her mobile phone six inches from her face, her whole attention world-occluding, fixed thereon. Downhill, posture contorting back and away, flowery bag over her shoulder, gargoyle-figure of a woman stares fixedly at her.

We might set the mind loose now, by way of experiment, on one of these moments that are separated out from the flux by infinitesimal gradations of the camera's shutter:

She dreams her from the straitened life into the secret wood, up past Cefn Coed, on a warm spring night by Ogof y Ci where the blind white trout swim their underground stream; the bed of emerald moss of which she has old memory, spring light dappling across…

You think not? No Rosie Proberts here, no singing assonance? You think because this is unromantic Gurnos? These lives so excommunicant? From Dafydd's woodland mass? Did you look for, did you *miss*, Max Boyce and his giant leek as your glance slipped across the moment at the Millennium Stadium?

The textural and the intertextual. There are the absences which define every photograph. For these two in Gurnos only the hooped bramble across the frame's corner, keeping them in? I wonder where you are coming from; and so do these photographs. Look at them as mere list of subjects from Welsh topography and the sense of something quite other than that which you will encounter here is aroused:

Expectations: Wales, the most beautiful, the first place, the landscapes-peerless of Ruskin and Shelley; Wales of chapel and rugby and miners and smoke-wreathed valley-side terraces; Wales of sheep-stippled slate-fenced hillsides and high shapely mountain ridges. Wales of the flooding gold diffused evening light from off the sea; Wales of the capes and cliffs and wheeling wild birds and offshore islands, old stones at the field corners, marts with the gnarled faces, the squat and solid men, crook-holding, watchful and wary; the penned and leaping sheep…

Ah! We are at the singing again. But you have seen and heard all that. And how often…!

You will not find it here. Instead a post-industrial Wales. Defeated miners, sold-off steel, supermarket sites. A muddy low-tide at Barry Docks, largest coal-exporting port in the world. Once. And the ring-of-steel castles of the Conqueror are gawped-at tourist attractions; even the landscape packaged and red-for-beware-geraniumed:

"Photographs bear witness to a human choice being exercised in a given situation. A photograph is a result of the photographer's decision that it is worth recording that this particular event or this particular object has been seen. If everything that existed were continually being photographed, every photograph would become meaningless. A photograph celebrates neither the event itself nor the faculty of sight in itself. A photograph is already a message about the event it records. The urgency of this message is not entirely dependent on the urgency of the event, but neither can it be entirely independent from it. At its simplest, the message, decoded, means: I have decided that seeing this is worth recording."
– JOHN BERGER, 'UNDERSTANDING A PHOTOGRAPH'.

Amuse yourselves now. Imagine what the opinions of those who promote tourism in Wales might be on whether or not *"it is worth recording that this particular event or this particular object has been seen"*. Would there be – resistance?

By the 'No Fishing' sign on Penarth Pier a man in high-visibility full waterproofs leans out of the rain into the window of the juice-and-coffee bar, the sea and sky gradations of grey barely differentiated by the horizon; the pavilion of the Netherlands National Circus squats in medieval travesty of form among cars and a slick glisten of mud at Barry Island whilst hunched figures, figures leading children, carrying children, bustle towards it, and two fat boys on mountain bikes wheel past.

So seldom is that which we see that which we wish to see.

Instead, we invent, or we interpret. Susan Sontag's dictum that *"Interpretation is the revenge of the intellect upon the world"* should always be borne in mind.

Remember too Foucault's warning: *"There is in this hatred of the present or the immediate past a dangerous tendency to invoke a completely mythical past."*
– MICHEL FOUCAULT, 'SPACE, KNOWLEDGE, AND POWER'.

Things are not as we would like them to be, let the gargoyle-human's gaze linger at the bus shelter long as it will. The fairies departed long ago, and all that stock of stories only gauzes or slenderly inhabits the mind-landscapes we might invoke.

A woman sticks her head through the toll-booth door at St. Fagan's; but it is in a museum now. There are no Rebeccas, no drovers, no everyday commerce or smoking fire in the hearth. She glimpses concept, thesis, explanation, objectification of the historiographical project, in a roving moment of semi-concentration whilst those infinitesimal time-gradations of the shutter freeze her.

In her puzzling predicament.

She will move on from here to re-planted barn and re-furbished stable and folk-life remnants painstakingly collected, restored, annotated. Some of these she will remember vaguely, glimpsed in period costume-dramas on the television, an industry extant to

research them. Where is Wales in all this, where in this folk-life museum the margin-alised *gwerin*[1] of today, and as to the *fro*[2], its cohesive structures gone (watch out for the chapels in these pictures of a present nation), how socially inclusive is its culture now? How much has vague notice of the eye in common with focus of the camera lens? And was she ever astride Kerr's Ass?

> *The winkers that had no choke-band,*
> *The collar and the reins...*
> *In Ealing Broadway, London Town*
> *I name their several names*
>
> *Until a world comes to life –*
> *Morning, the silent bog,*
> *And the God of imagination waking*
> *In a Mucker fog.*
>
> PATRICK KAVANAGH, 'KERR'S ASS'.

In a Mucker fog...! We will consider the light in these photographs bye-and-bye, and colour too. Firstly, the implication of Kavanagh's verses – their implicit assertion of imagination's dependence on real familiarity with what has gone before (pay heed here to Foucault's warning!) The plight of that woman-observer slinks back into notice. Our sub-conscious dependence on knowledge of tradition, the way her enquiring figure flags it up; and all that loss. A passage from the Welsh-born folk-historian George Ewart Evans to elaborate around the point:

"I have suggested that the old rural society was society's unconscious, possessing two more-or-less distinct levels like the unconscious of the individual: the preconscious into which sink out-dated customs, half-forgotten science, outmoded fashions, and words and phrases once the coin of polite conversation but gradually demoted into the rural dialect; and beneath this at a level more rarely exposed the true phylogenetic unconscious where the most archaic beliefs and modes of thinking have lasted until recent years. This level is a rich repository of much of the rural history of these islands. Yet historians whose stance appears to have anchylosed in the correct atmosphere emanating from nineteenth-century 'scientific' history have rarely attempted to bring this evidence of irrationality within their purview."
– GEORGE EWART EVANS, 'THE PATTERN UNDER THE PLOUGH'.

I have no argument with Evans's perceptions here, think them helpfully suggestive and in the main quite accurate. Also, they align significantly with the elliptical, graphic intertextualities of James Morris's photographs. With their sense of ongoing history, colonised national status, marginalised or subverted identity.

These images to me are extraordinarily moving, disturbing. They take implicit account of all the valences in prior treatment of Wales by other photographers and ever so politely question around authenticity, purity of intent, by presenting a set of images where rhetorical content is triple-distilled to highest proof: history mashed in, romantic aesthetics boiled off, folk-narrative boiled off; and what is left is clear, singular and fiercely resonant.

What is left...

As to the nature of that and our attempts to evade it, James Morris rather plays with us. He scatters, for example, throughout his sequence of images, sardonically almost, or at least teasingly, certain verbal clues: *Original Barmouth* and the bulky, aimless figures in their cropped-trouser uniforms picking with bowed heads through holiday goods, more inflatable tat stacked ceiling-high in the first-floor window above – of *Cloud Nine*. Here is *Sunnysands* Caravan Park, Gwynedd, its sea-wall boulder-defences, its grey waves and gravel, its chalets along a harsh and beachless coast.

I no longer live in this small nation, and yet it is the country of my blood and of my heart. Something I wrote two years ago, as I left: *"From all of this association begun in my formative years and continued down to the present day there has grown a peculiarly intense relationship or even identification with this particular landscape of Wales, which is so unlike any other that I've encountered in journeys worldwide. And yet the land has changed by drastic degrees in the course of the years. The quarrymen and shepherds of whom I knew so many in the past – sacks over their shoulders, blue scars, folklore and magic in their world-view, hospitality in their hearts and democratic spirit in their daily intercourse – have vanished from it. No child could walk alone – as I did fifty years ago – into a welcome here now, nor gain from their liberal education. An alien wind has blown in. The old cottages have had their makeovers, the Range Rovers are parked outside, and the people who knew of place in its every resonance are dispossessed, marginalised, whilst the land itself is abused and betrayed: renewables, resources, recreation slip in as buzz-words for the intellectually vacuous and the new-devout (who care nothing for landscape's spiritual significance); and alongside them the obsessive materialism of our whole nation, to which the hills and their old ways stood for me as resistant symbol."*

Foucault's warning about a mythical past should not make us timid about considering what was real, what was valuable – valent even, possessed of competence and power – and has now gone. The art of statement by selection of image, meaningfully pursued, also necessarily comprehends omission and absence.

Let us now consider an implied complex narrative constructed in these images around the national colour red:

Red road-sign for Bethlehem; red 'no entry' sign at Caerffili Castle; red faux-national costume outside the red smallest house; red logo of the Dragon Hotel at Swansea; red gas bottles at Greenacres Caravan Park; red lifebelt by the misplaced Hyddgen memorial; red chairs (not bardic but plastic, one broken in the mud) and red rain-capes under the grey tubular steel arc-en-ciel of the International Pavilion; a red dog-shit receptacle at Townhill; red in the crowd at the Royal Welsh and on the street on match-day in Cardiff; a red sign for toy trains at Llanfairpwll; red plant and netting on a Llanelli supermarket construction site; a red 'to let' sign among boarded dereliction in Caerffili; pensioner's red skirt in Llandudno; red Pepsi-Cola loop and Tesco Extra and Metro signs; red car in Ebbw Vale; a red Snowdon Mountain Railway carriage, photographer's tripod by a red rucksack nearby remotely pointed at a group, their whole attention world-occluding, fixing their own images upon a landscape; red van pinpointed in the converging angle of paths at Pen-Pass, red shed at Holyhead allotments, and a red-painted house for the bridge of the blessed ford. There is even a red absence – that of the red flags forever kept flying to signify no entry again at the Sennybridge battle ranges; which were taken from the people of Wales on a promise of return by the English war-machine and were never given back, the farms bricked up, the chapels and even the stone circles of older times shelled...

"Photographs bear witness to a human choice being exercised in a given situation"? Croeso i Gymru![3] At least, in the once-green land, there are the cabbages of Cadoxton, prize and magnificent. But no industry, no steelworks – the *Angry Summer* of the miners has given way to the aimless one of tourism. Above the last colliery, roadside memorials, ambiguously. Here in the Pyrenees, last year in my small local decaying proud industrial town at its thriving art-nouveau cinema Le Casino, I saw a magnificent and heartfelt French documentary, *Charbons Ardents*, about the workers' buyout of this self-same Tower Colliery above Hirwaun. How often has this film been seen in the country of its setting?

Consider the ironic eye. We can turn it back, mischievously, on its possessor: James Morris, famously, beautifully, painting with light and shade, the recordist of rich organic textures of indigenous mud buildings in Butabu. And of Welsh pervasive liquid mud under frailing mist-fingers of Welsh skies.

Light, I said we would come back to. How uniform it is here, and how unilluminating. How brave and challenging to present it thus. The people so often without shadows. Remember your folklore? On Friars Point at Barry they are Lowry matchstick figures, flocking towards the cliff-edge, freighters and aeroplanes heading down-channel and out-of-frame.

There is no sneering in this book, only profound observant sadness.

"Wylaf wers, tawaf wedy" – I shall weep for a while, then be silent. We are good at elegies, us Welsh:

> *"Stauell Gyndylan a'm erwan pob awr,*
> *Gwedy mawr ymgyuyrdan*
> *A weleis ar dy benntan."*

(Hall of Cynddylan each moment pierces me/With memory of great talk/I witnessed at your hearth.)

As verbal epigraph to this book, grim old R.S. Thomas's poem, 'Reservoirs':

> *"There are places in Wales I don't go:*
> *Reservoirs that are the subconscious*
> *Of a people..."*

There, facing, as intertextualising visual epigraph, is a photograph of Craig Goch, Elan Valley. A blank and rusting sign points into the photograph; puddles stretch across the roadway atop the curving dam; there is a 'No Through Road' sign, an interpretation board and a pewter stretch of water between bracken spurs of sodden terracotta under a grey sky. A wire fence stretches across the foreground. Remember, these are not snapshots, not chance observations lightly picked, but photographs carefully composed using a heavy 5x4 plate camera. Remember Berger on the photographer's decision and choice? What's been dispensed with throughout is this:

> *"...a watercolour's appeal*
> *To the mass, instead of the poem's*
> *Harsher conditions."*

I am uneasy around the notion of 'the mass', recall too the resistance to R.S.'s poetry among an older generation of Welsh people; not an outright anger, but an offence taken at the gloom and the grim caricaturings. It would be very easy, I think, on viewing these photographs, to resort to the rhetoric again, to expound on aesthetics, think in terms of subtopias and dystopias and begin quoting D.H. Lawrence at his most vehement:

"...the promoter of industry, a hundred years ago, dared to perpetrate the ugliness of my native village. And still more monstrous, promoters of industry today are scrabbling over the face of Britain with miles and miles of red-brick 'homes', like horrible scabs. And the people inside these little rat-traps get more and more helpless, being more and more humiliated, more and more dissatisfied, like trapped rats."
– D.H. LAWRENCE, 'NOTTINGHAMSHIRE AND THE MINING COUNTRYSIDE'.

There are obvious dangers in this line of argument, but those dangers should not deter us from the great socialist writer Gramsci's imperative to *"turn violently and face things as they really are"*. Here are the graphic images of what is being done by government,

industry and developers to our land, and its effect on the inhabitants. Study it in the faces on Llandudno pier and along the promenade; consider the aimlessness, the unfocussed searching; look at the external aesthetics which are the conditions imposed on these lives, spent among historical relics in process of being rendered meaningless.

Consider the affronts: an arbitrary shipping container alongside Hyddgen's remote memorial, with a road-sign between them bearing an exclamation mark; private housing estates at Ty Ddewi and Llanelli that seem the same place, all individuality – even of one of the holy places – entirely lost; a gas pipeline at Trecastle, through the Brecon Beacons National Park; and forestry, clear-felled, the land like a battlefield scarred, soured and ruined, washed away even down the drainage ditches, silting the rivers and lakes. Sixty years ago, as the mass afforestation project began which was to destroy Welsh rural communities and traditional ways of life, a government spokesman asserted that *"we intend to change the face of Wales. We know there will be opposition but we intend to force this thing through."* At the present time the government is intent – and is providing a billion pounds in enabling funding for the project, much of which will be siphoned off by the usual fraudsters – on massively increasing the numbers of wind-turbines, the presence of which along with their ancillary works in entirely inappropriate locations throughout the Welsh hills is yet another act in the ongoing affective destruction of the natural landscapes of Wales.

Atrocities…!

To record a landscape not in terms of familiar and clichéd images of its remnant natural beauty, but in terms of our brutal unawareness of and disregard for it and its indigenous culture is a radical and necessary enterprise.

Consider too in these images – in Lawrentian terms, if you must – the imposition of harsh and angular human geometries of form on the sweeping, organic shapes of the land. Consider the ontological force – and I re-visit this image continually to puzzle out the technical means by which it gains its power – of the ten-storey Swansea tower-block. How distant we have become from the natural matter of life, how abusive of it, how lost and wondering?

"Devotees of post-war planning could… stand here and trace the fading outline of the ideal geometry that post-war public authorities dreamt of imposing… the zoning, the distant green belt, the clearances and huge new estates, the roads…"
– PATRICK WRIGHT, 'A JOURNEY THROUGH RUINS'.

Susan Sontag in her seminal extended essay on photography from nearly forty years ago wrote – echoing and borrowing from Herbert Marcuse's great *Essay on Liberation* – that: *"A capitalist society requires a culture based on images. It needs to furnish vast amounts of entertainment in order to stimulate buying and anaesthetize the injuries of class, race and sex. And it needs to gather unlimited amounts of information, the better to exploit the natural resources, increase productivity, keep order, make war, give jobs to bureaucrats. The camera's twin capacities to subjectivise reality and to objectify it, ideally serve these needs and strengthen them. Cameras define reality in the two ways essential to the workings of an advanced industrial society: as a spectacle (for masses) and as an object of surveillance (for rulers). The production of images also furnishes a ruling ideology. Social change is replaced by a change in images."*

Putting aside for the moment those degrading bargains struck with the populace which were at the root of Marcuse's argument – and which are evidenced here by the beggarly streets of Ebbw Vale, satellite-dished to receive their dole of soaps, sport and porn – might it be that Sontag has it wrong in limiting the camera's capacities to reality-definition by surveillance and the provision of spectacle?

Is the camera not also, in the hands of technicians of sacred truth, as here a mirror, a means potentially to a liberating awareness, a looking-askance at the glass beads given in exchange for the land; and through that, the quiet and revolutionary anger at last having been kindled, of concerted resistance to the destruction of that which we should hold most dear? The God of imagination waking / In a Welsh fog? Instilling in us the profound and essential truth about our land which the poet Robert Williams Parry, of Talysarn, so memorably and simply expressed?

> *"Y mae lleisiau a drychiolaethau ar hyd y lle."*
> (There are voices and phantoms throughout the place.)

They are present in these crucially important images, that give up level after level of meaning to an attentive regard. Hear them. See them. The better part of your living requires that you attain this awareness. As does the Welshness of Wales, and any prospect there may be of its survival.

ARIÈGE, JANUARY 2010

1. *Gwerin:* people
2. *Fro:* heartland of the Welsh language
3. *Croeso i Gymru:* Welcome to Wales

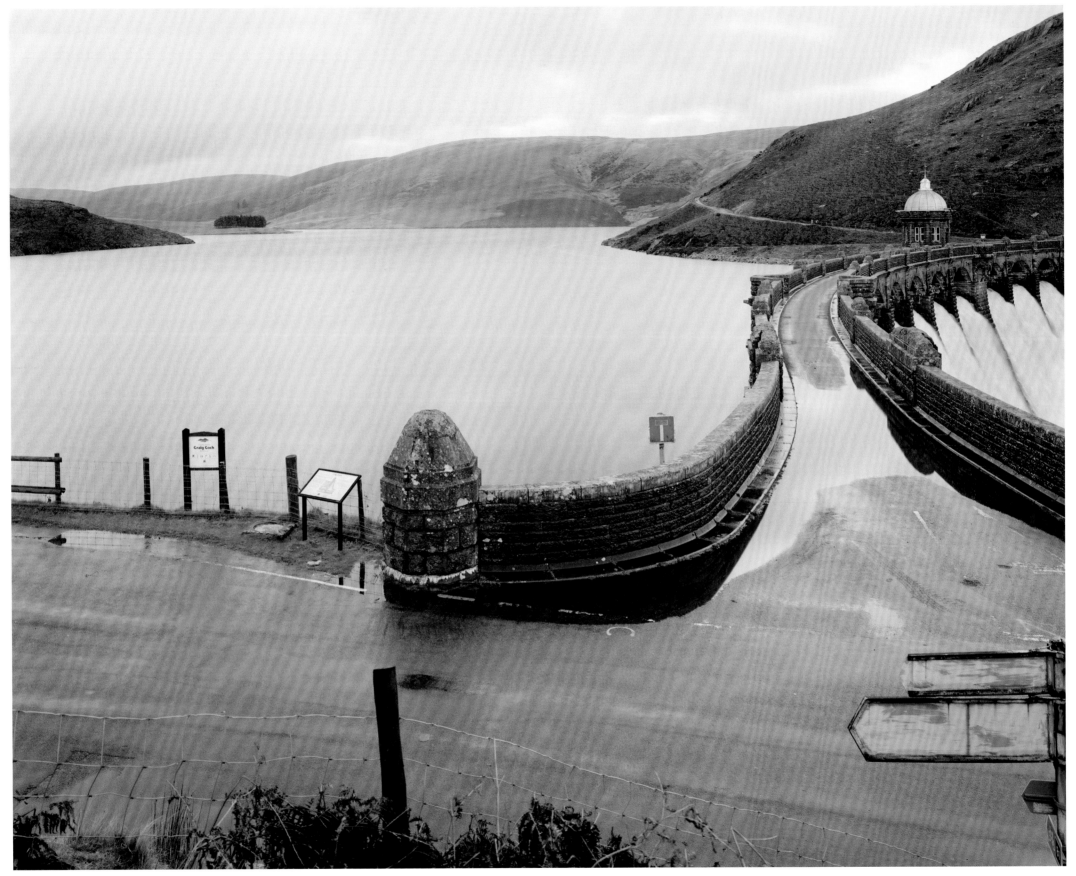

Craig Goch, Elan Valley, Powys

RESERVOIRS R.S. THOMAS

There are places in Wales I don't go:
Reservoirs that are the subconscious
Of a people, troubled far down
With gravestones, chapels, villages even;
The serenity of their expression
Revolts me, it is a pose
For strangers, a watercolour's appeal
To the mass, instead of the poem's
Harsher conditions. There are the hills,
Too; gardens gone under the scum
Of the forests; and the smashed faces
Of the farms with the stone trickle
Of their tears down the hills' side

Where can I go, then, from the smell
Of decay, from the putrefying of a dead
Nation? I have walked the shore
For an hour and seen the English
Scavenging among the remains
Of our culture, covering the sand
Like the tide and, with the roughness
Of the tide, elbowing our language
Into the grave that we have dug for it.

For my mother, who loved Wales.

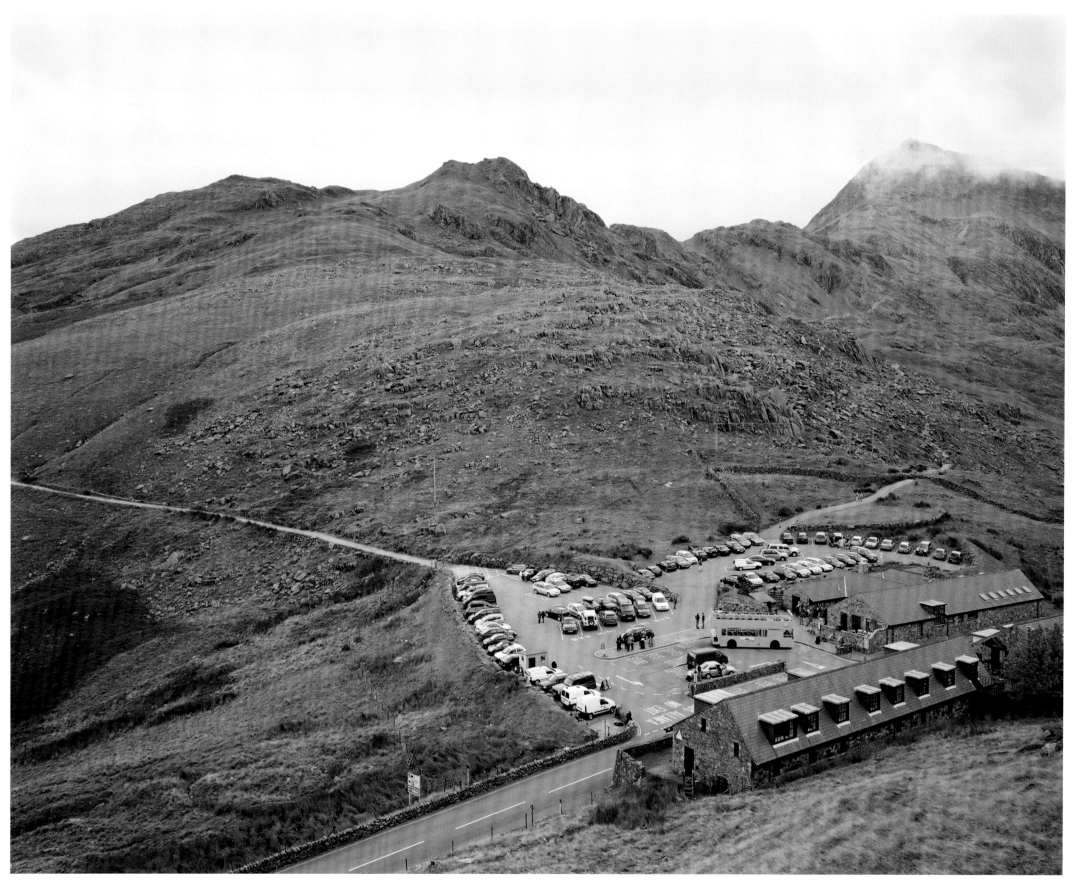

Llanberis Pass, Snowdonia, Gwynedd

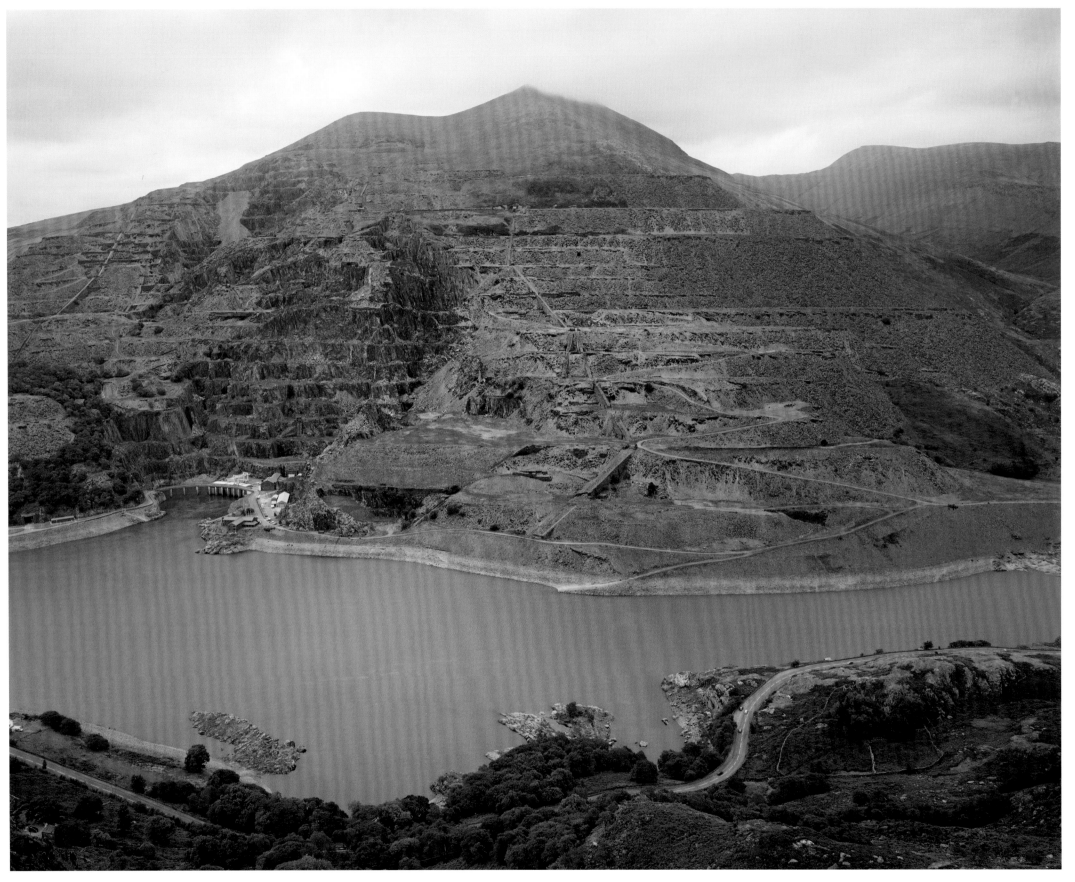

Dinorwig slate quarry (disused), Gwynedd

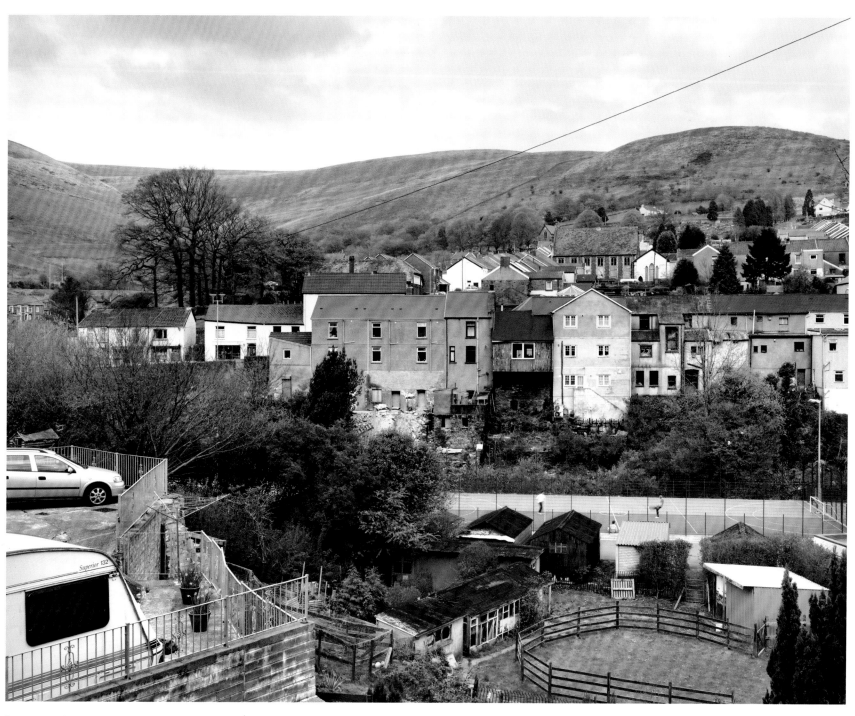

Pontyrcymer, Garw Valley, Bridgend

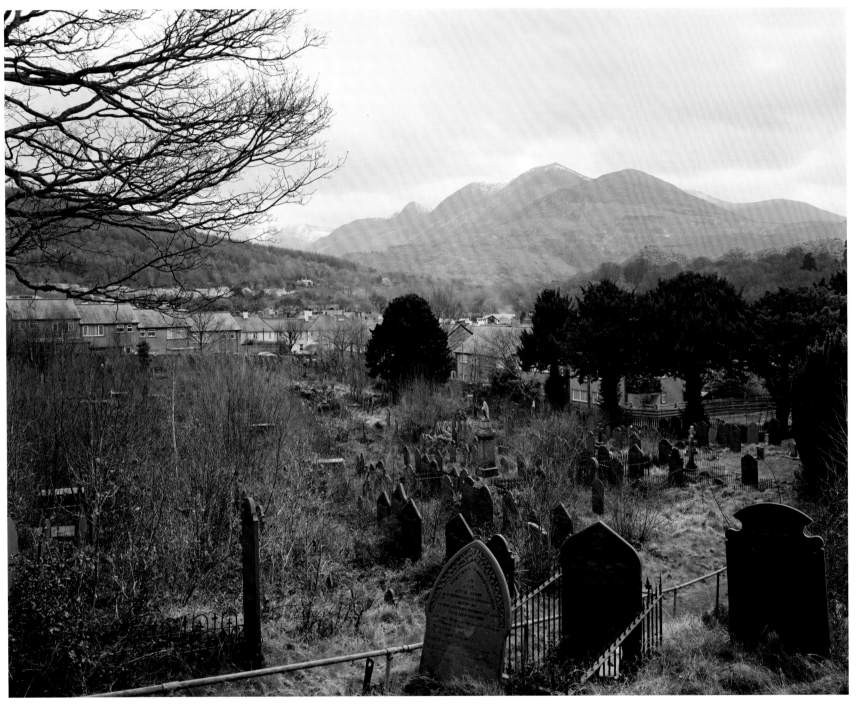

Bethesda, Gwynedd

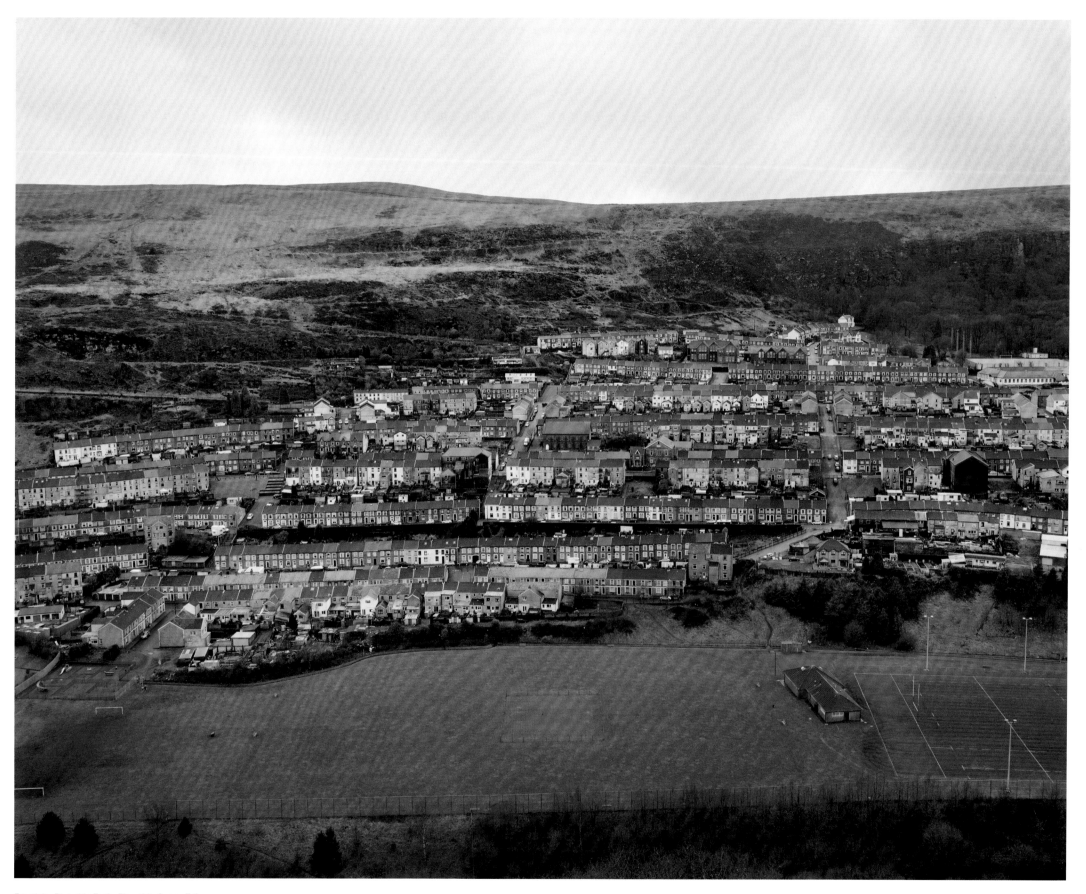

Ferndale, Rhondda Fach, Rhondda Cynon Taf

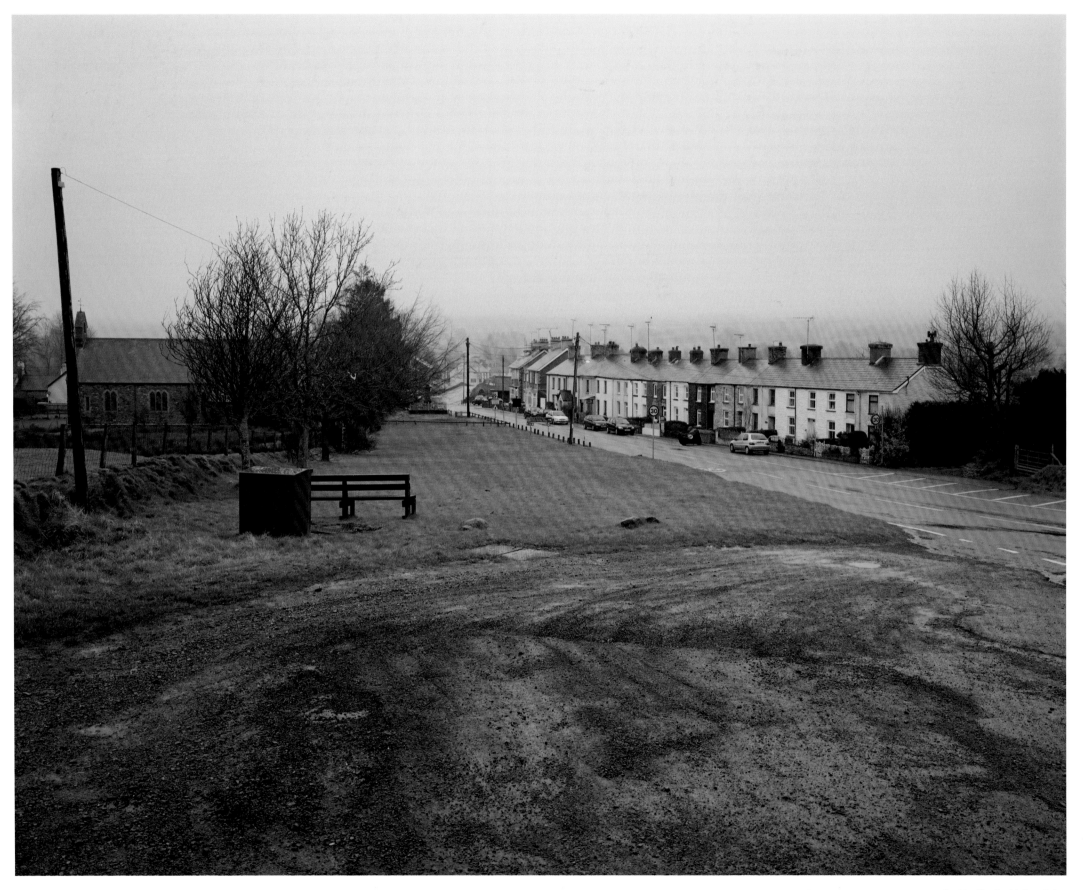

Pontrhydfendigaid, Ceredigion

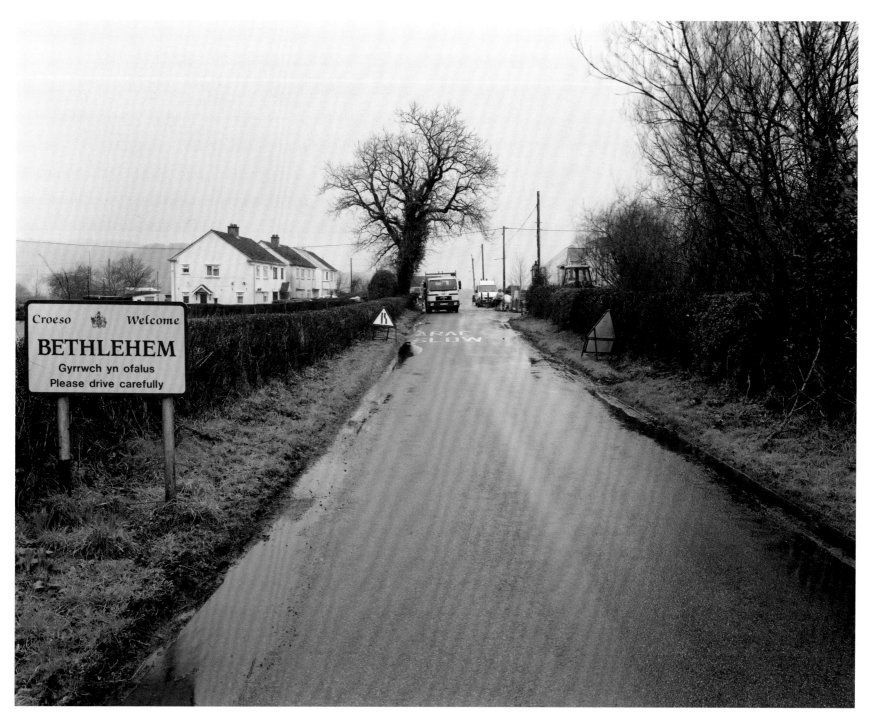

Bethlehem, Carmarthenshire

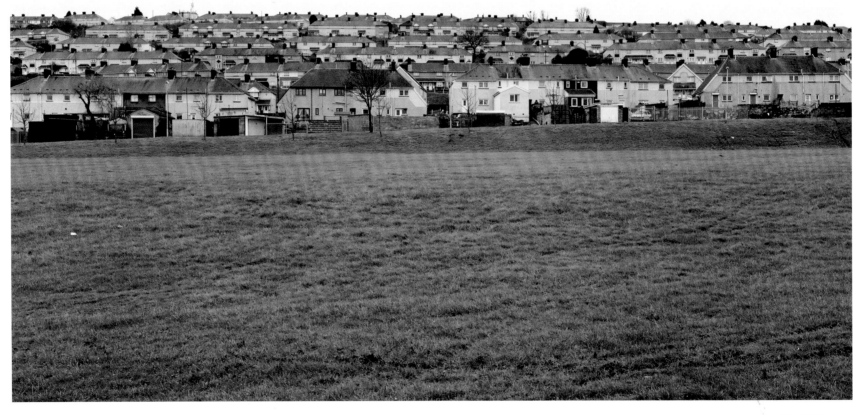

Mayhill, Swansea

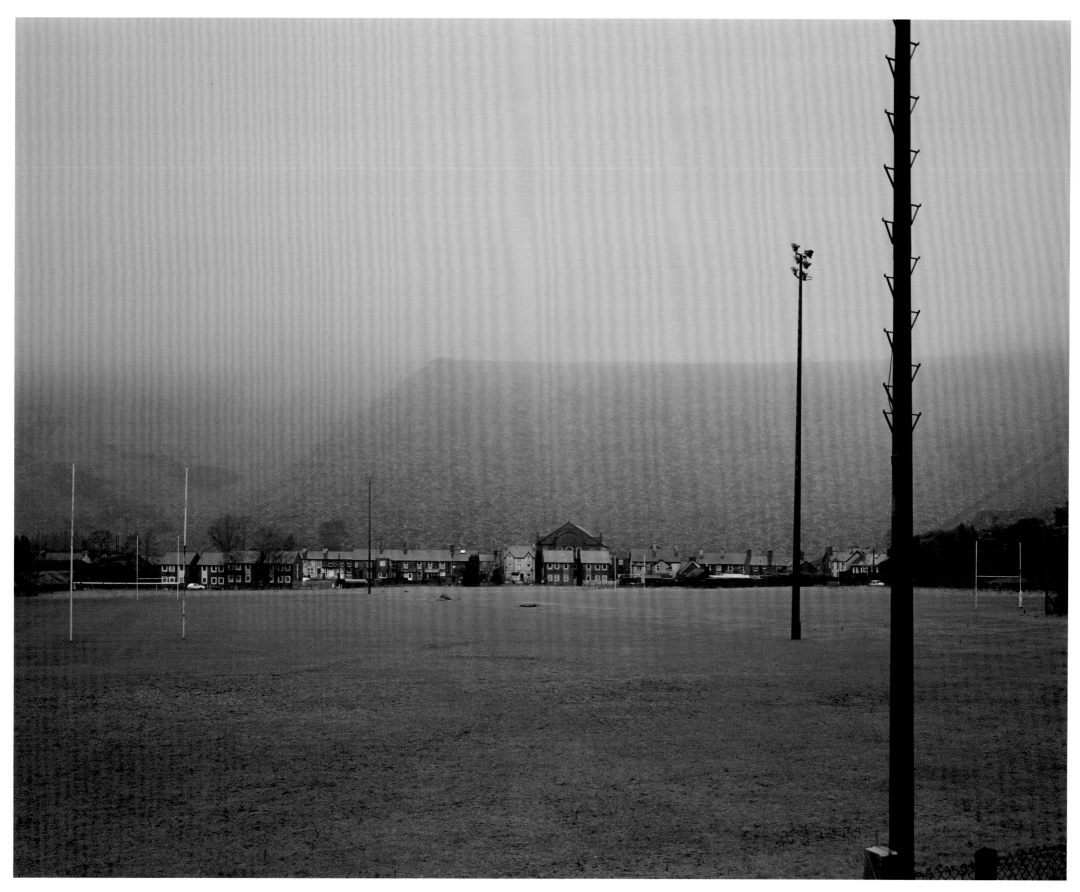

Blaenau Ffestiniog, Gwynedd

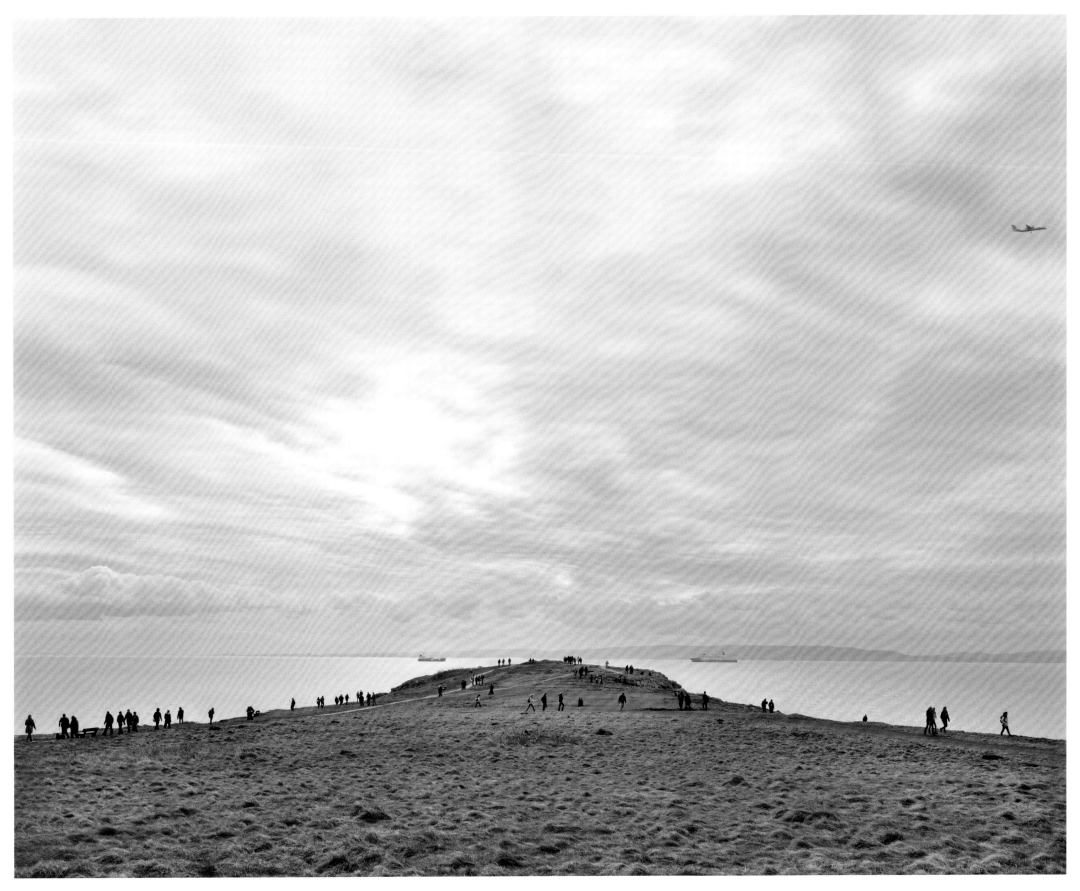

Friars Point, Barry, Vale of Glamorgan

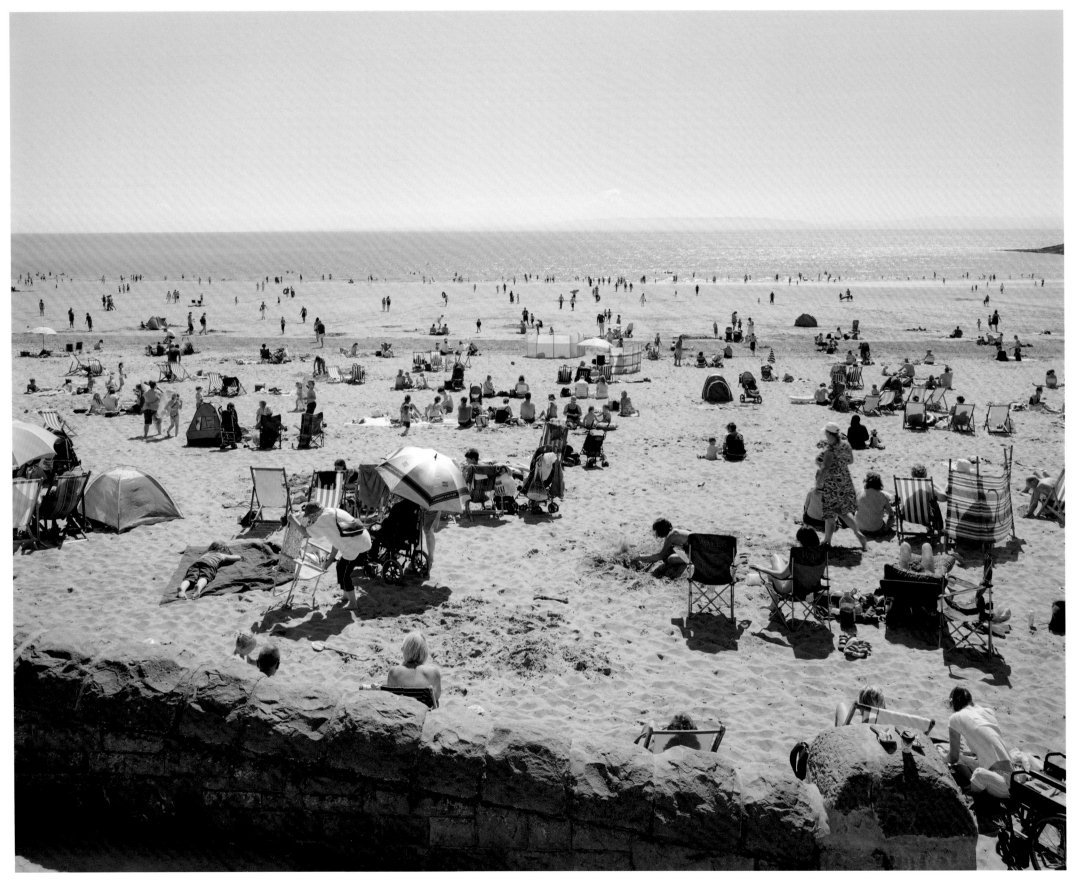

Barry Island, Vale of Glamorgan

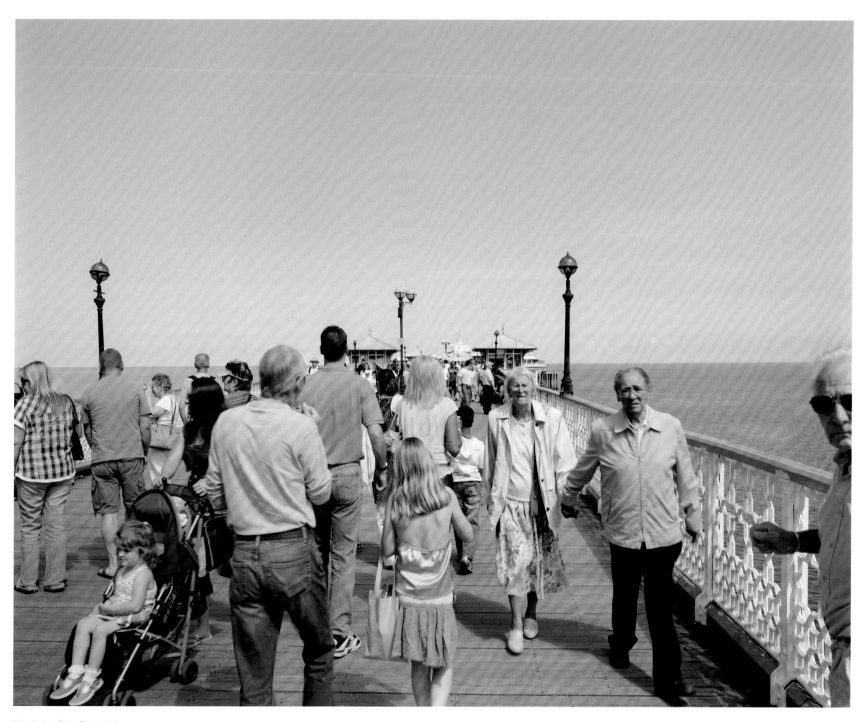

Llandudno Pier, Gwynedd

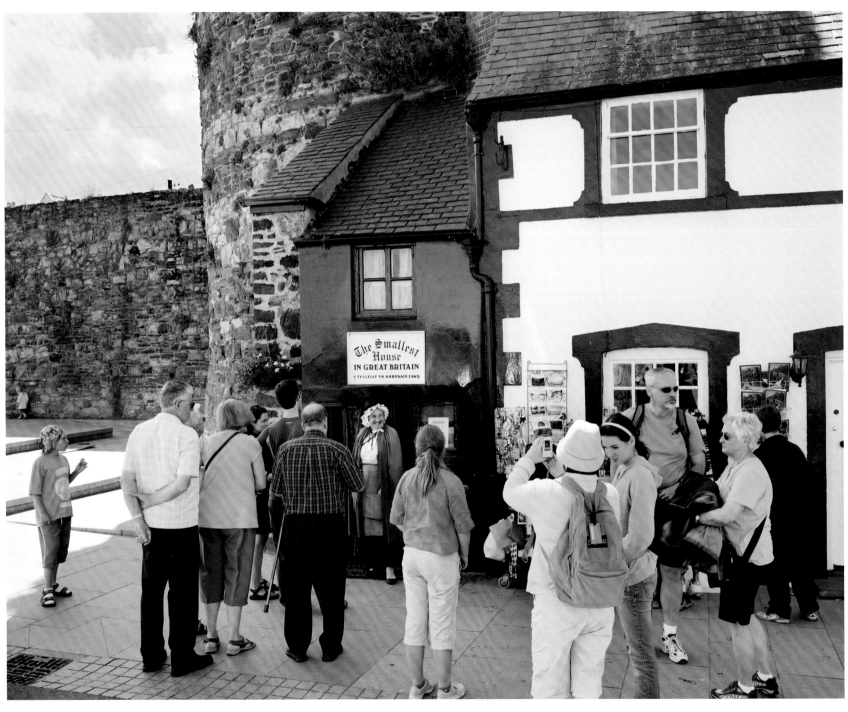

Conwy, Gwynedd

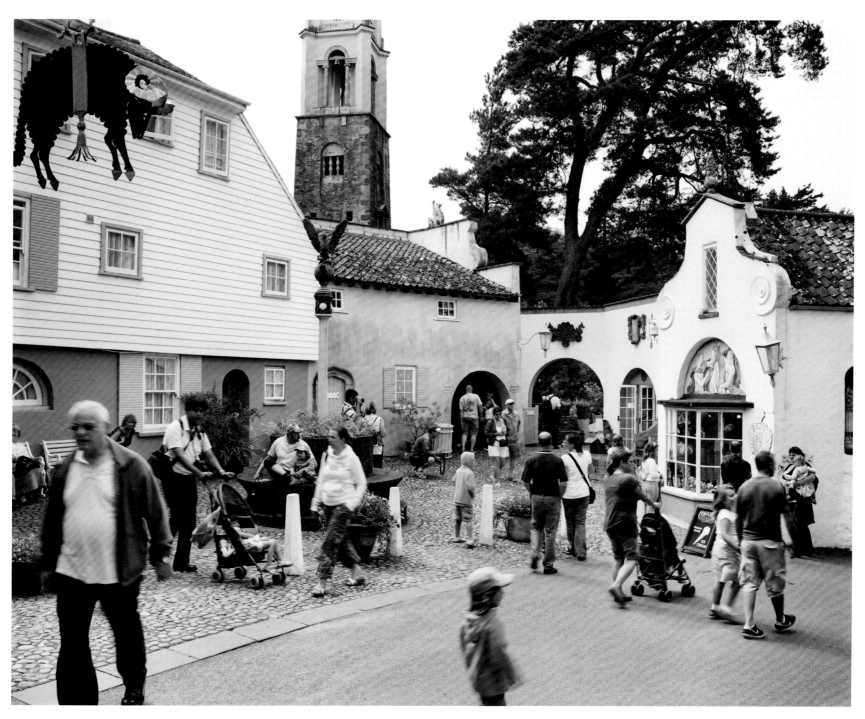

Portmeirion Village, Gwynedd

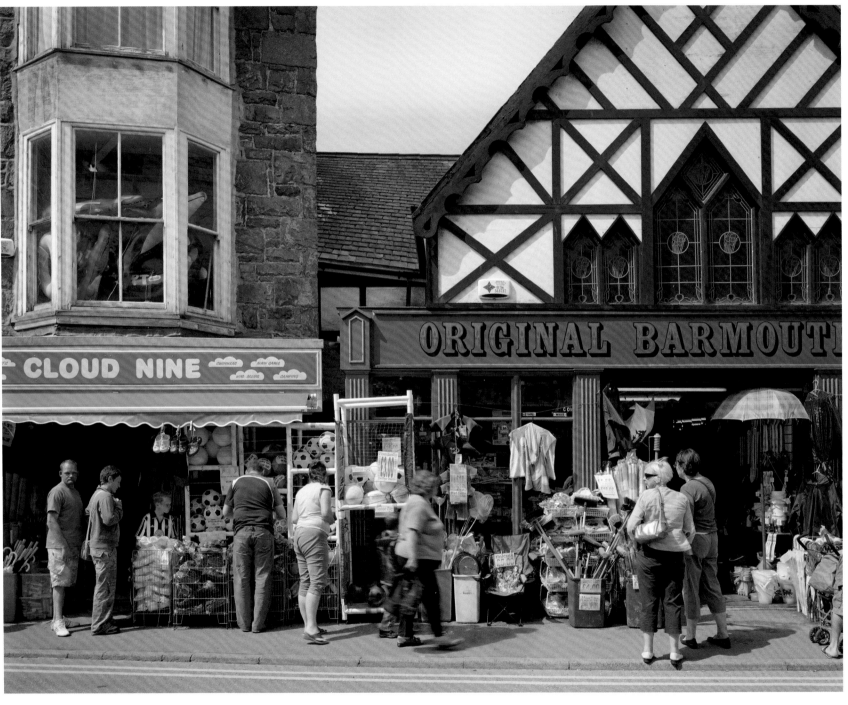

Barmouth, Gwynedd

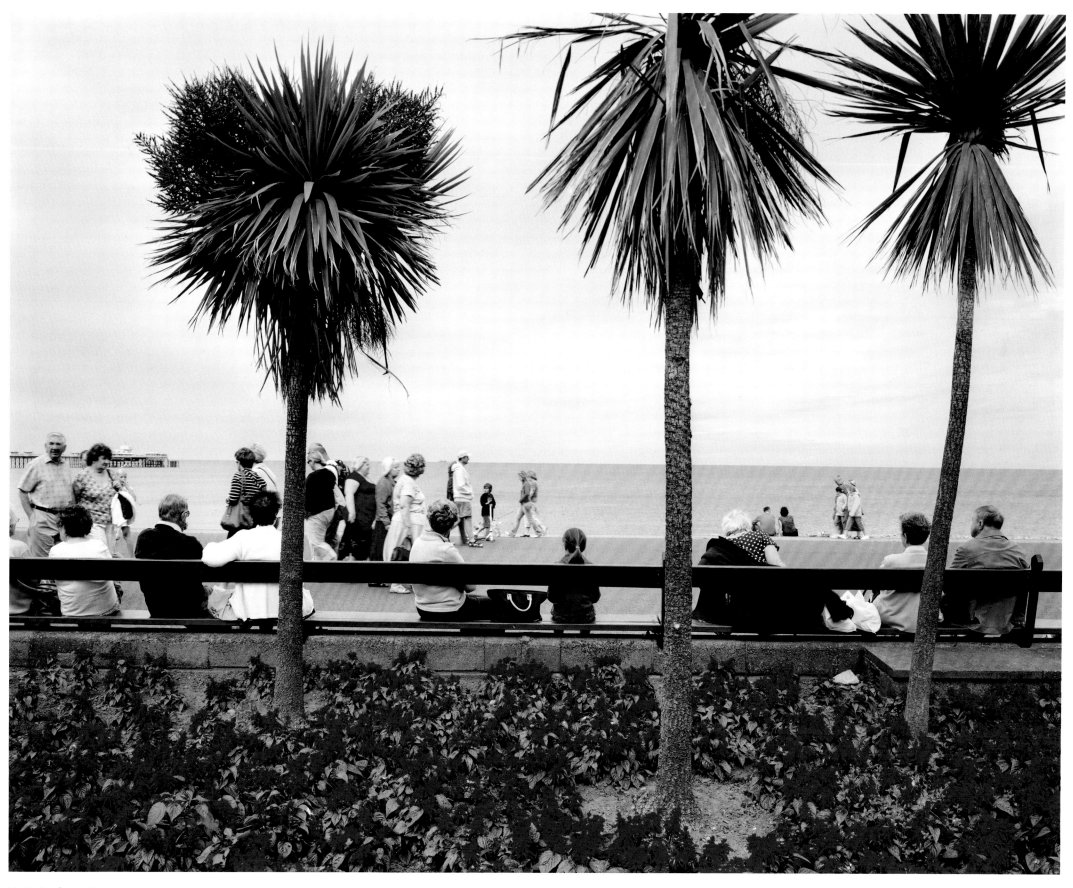

Llandudno, Gwynedd

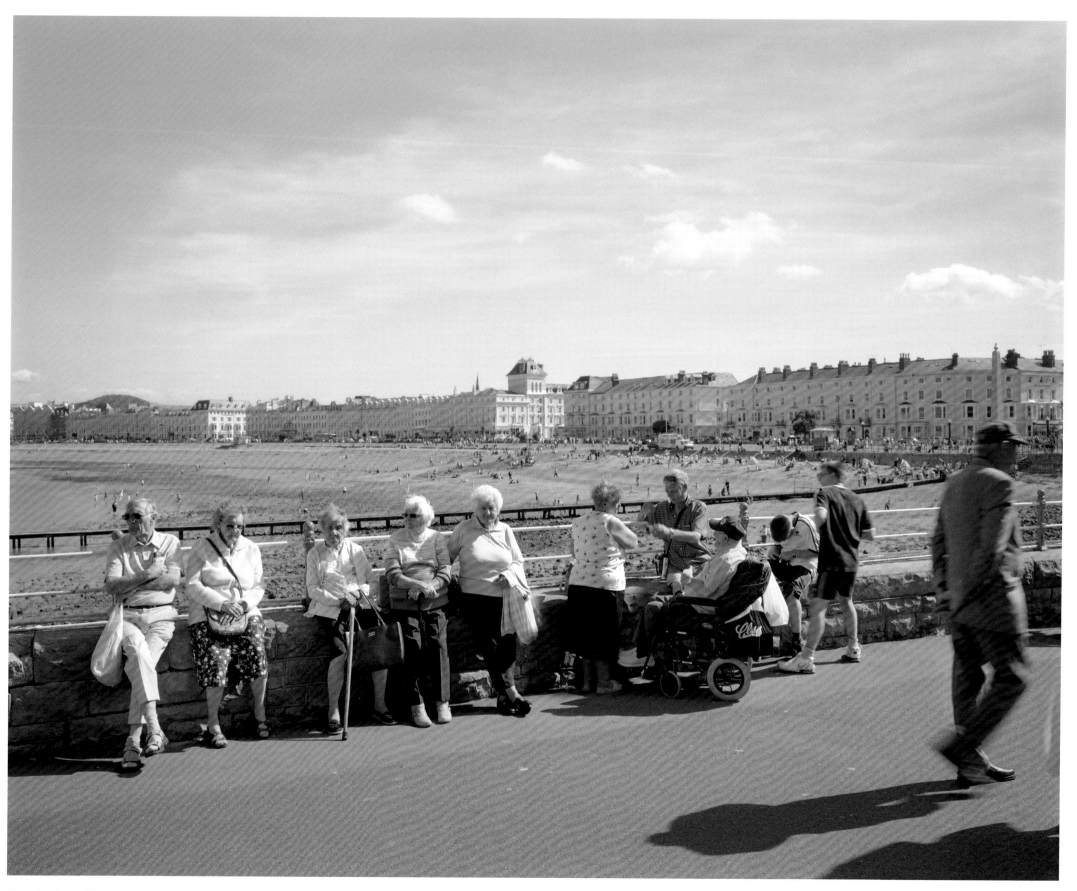

Llandudno, Gwynedd

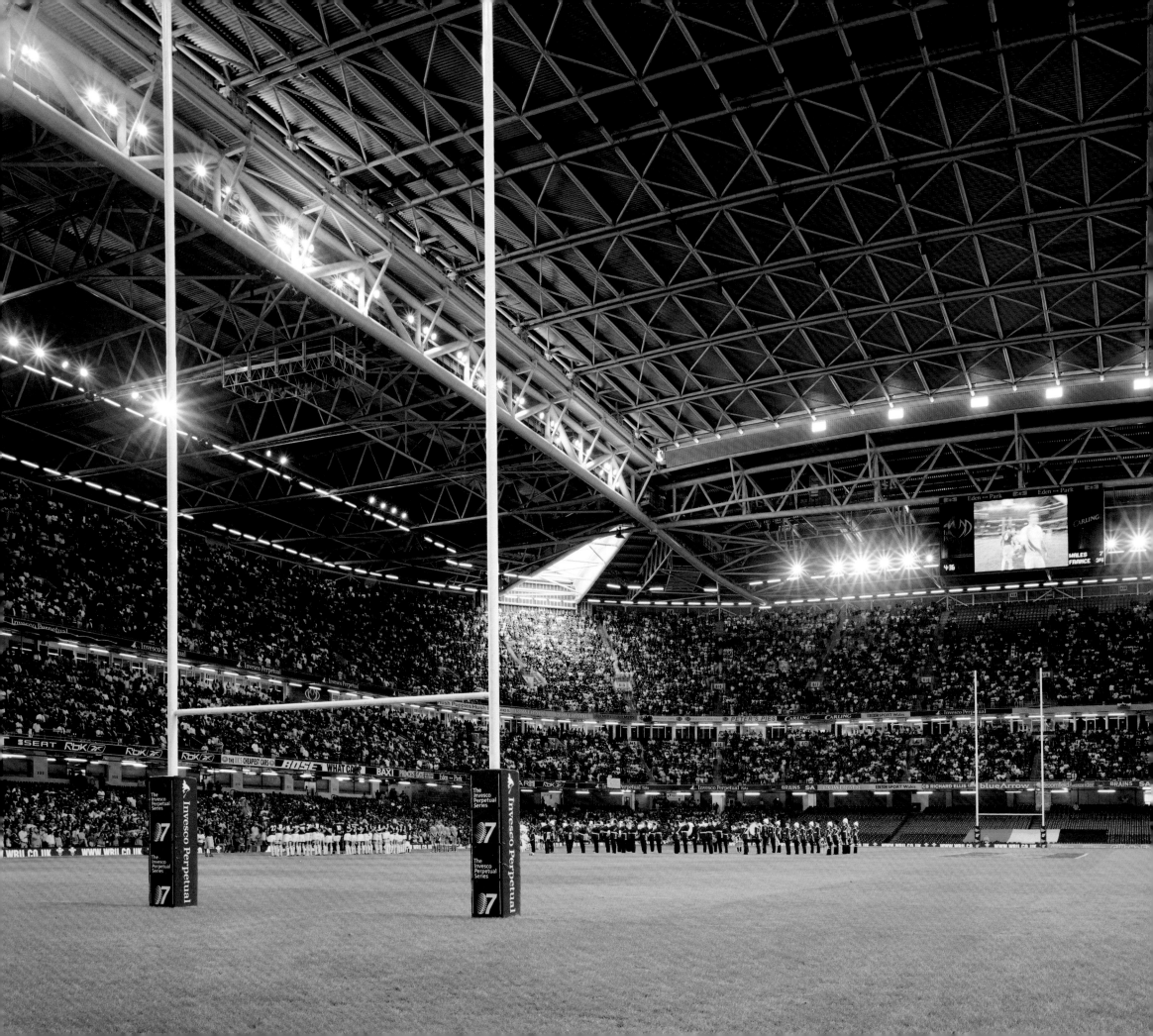

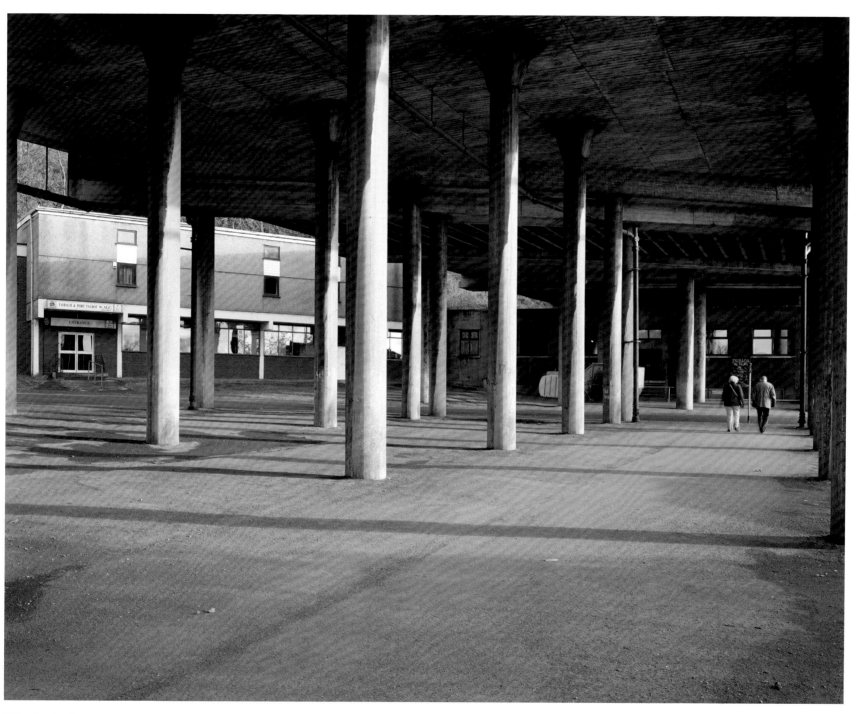

Millennium Stadium, Cardiff / Under the M4 Motorway, Taibach, Neath Port Talbot

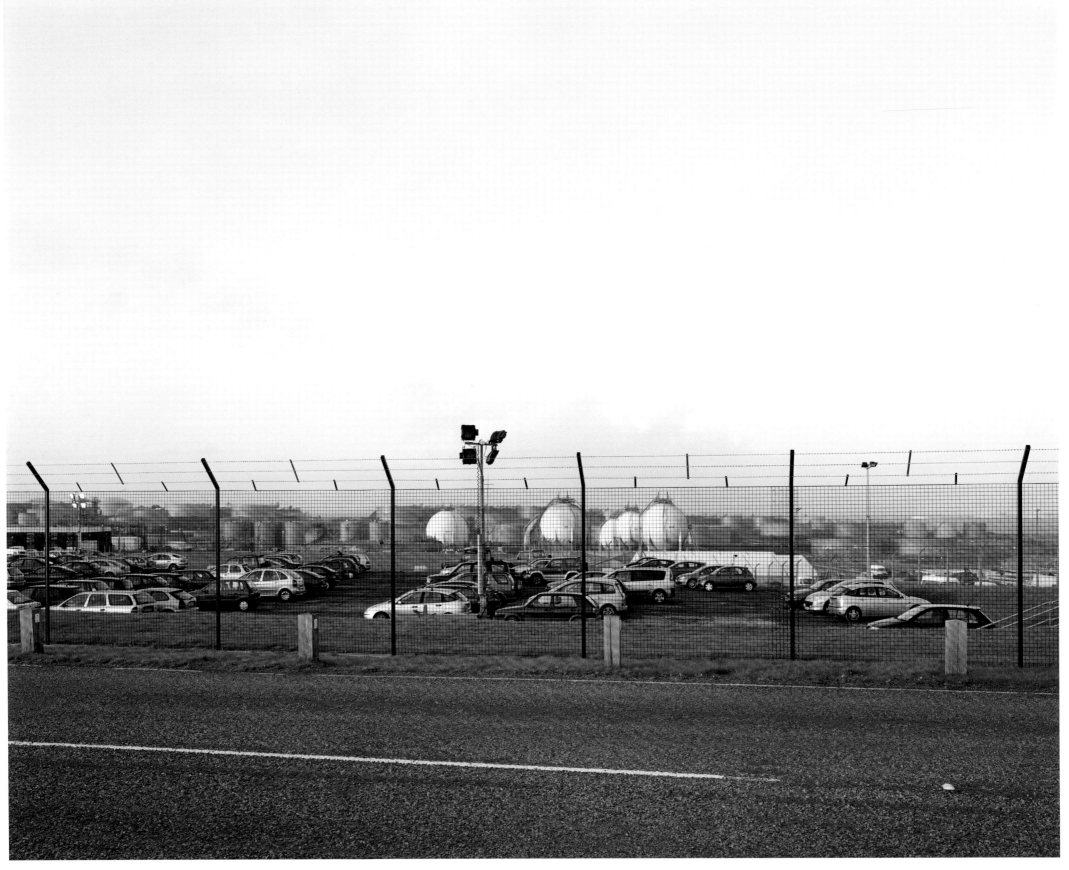

Popton Oil Refinery, Rhoscrowther, Pembrokeshire

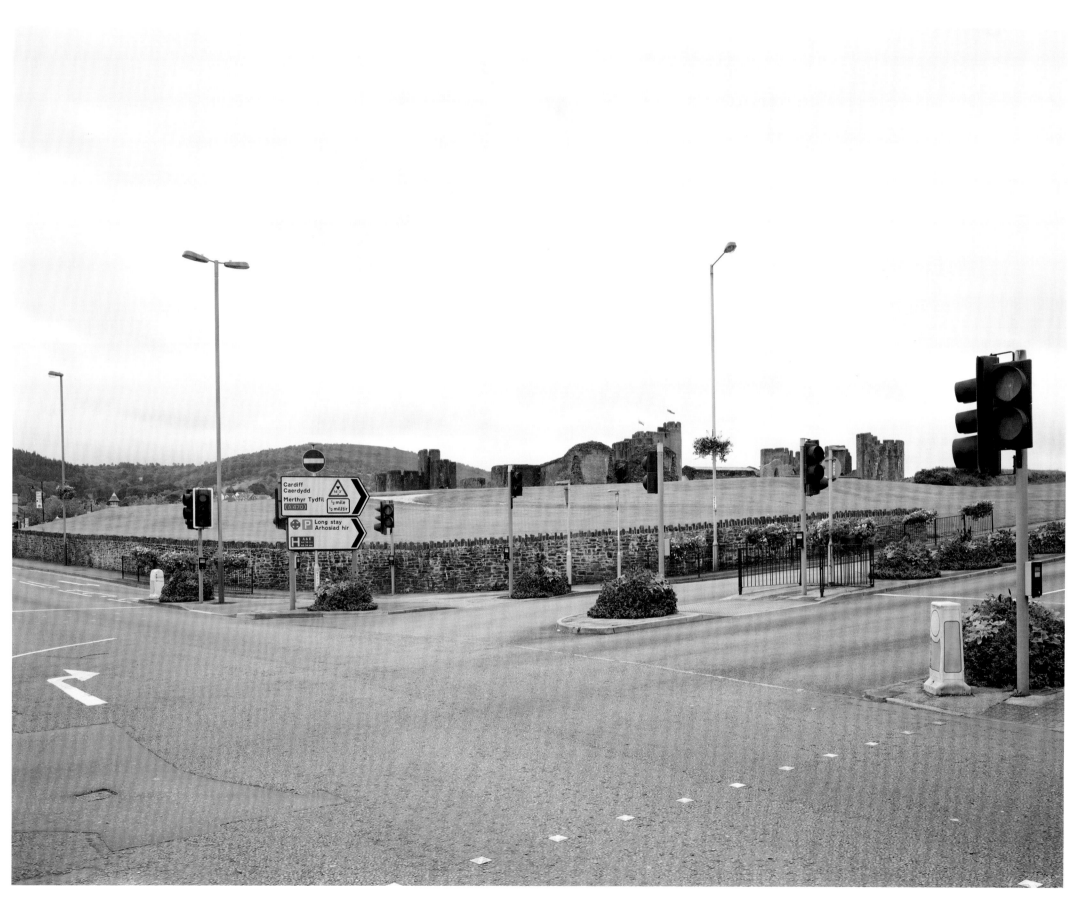

Caerffili Castle, Caerffili

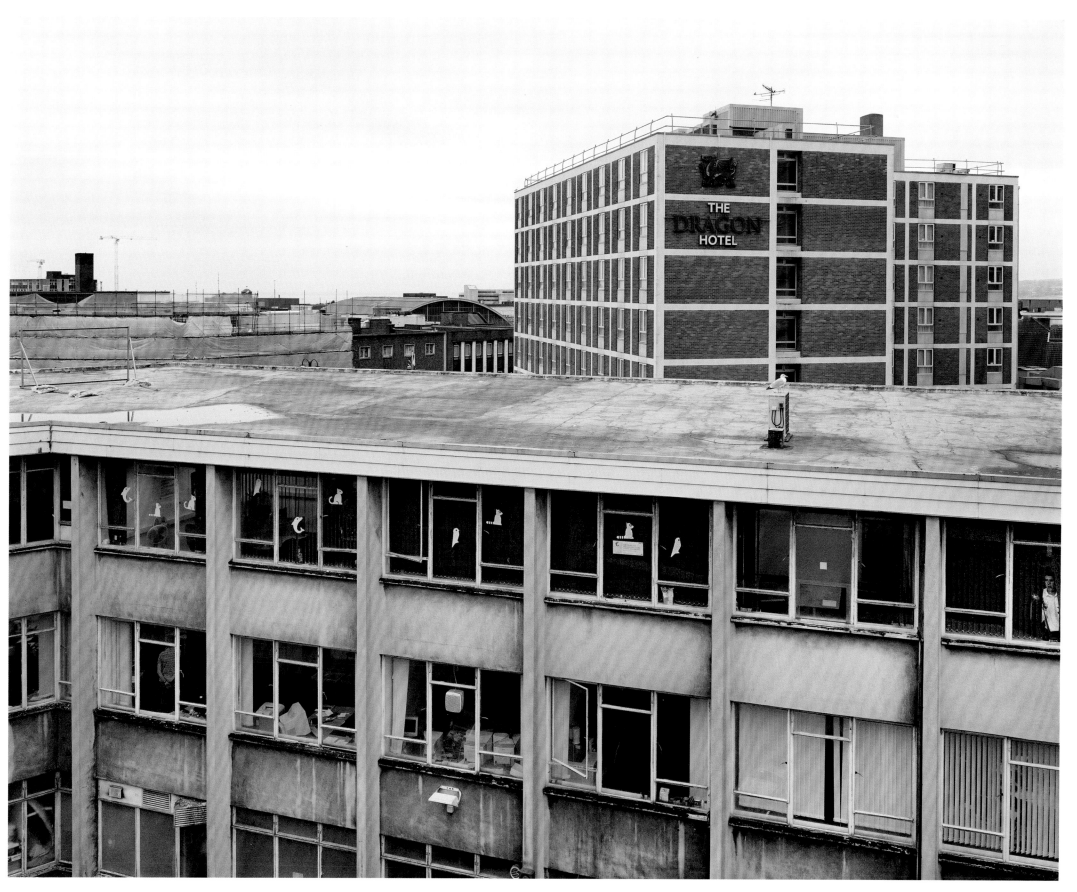

Dragon Hotel, Swansea

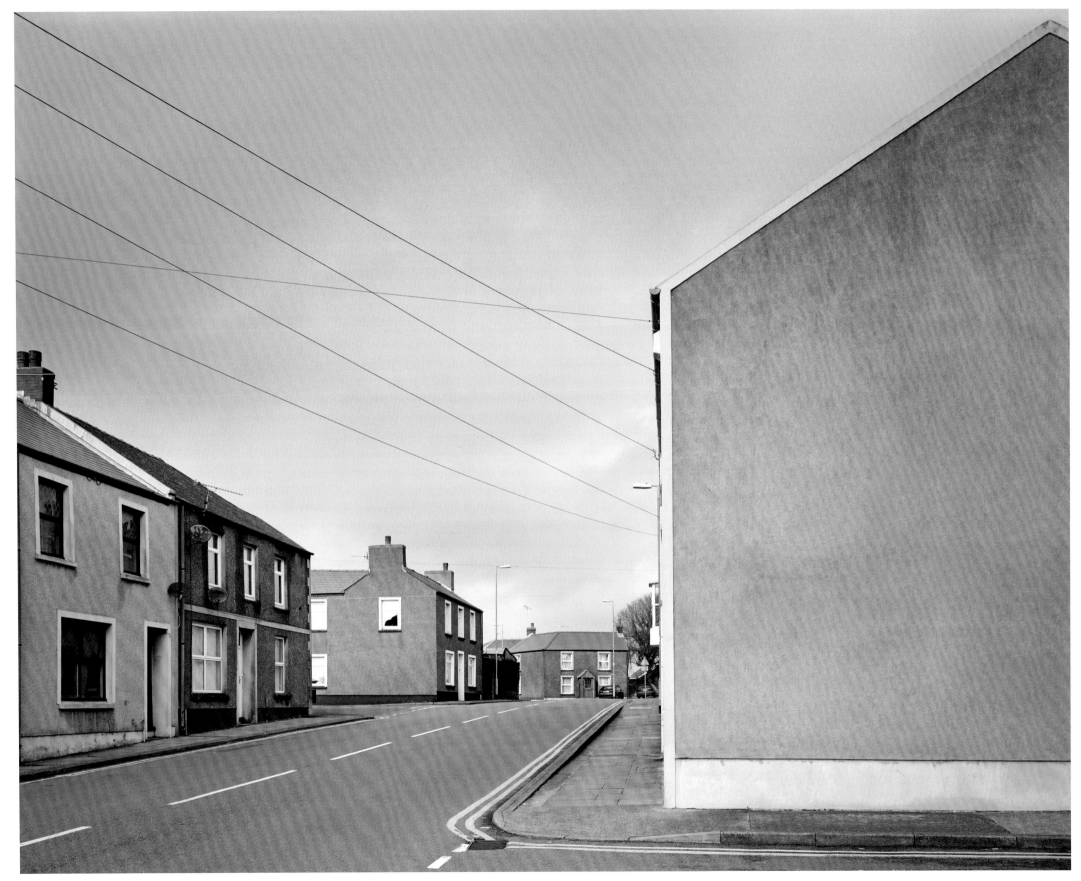

Neyland, Pembrokeshire

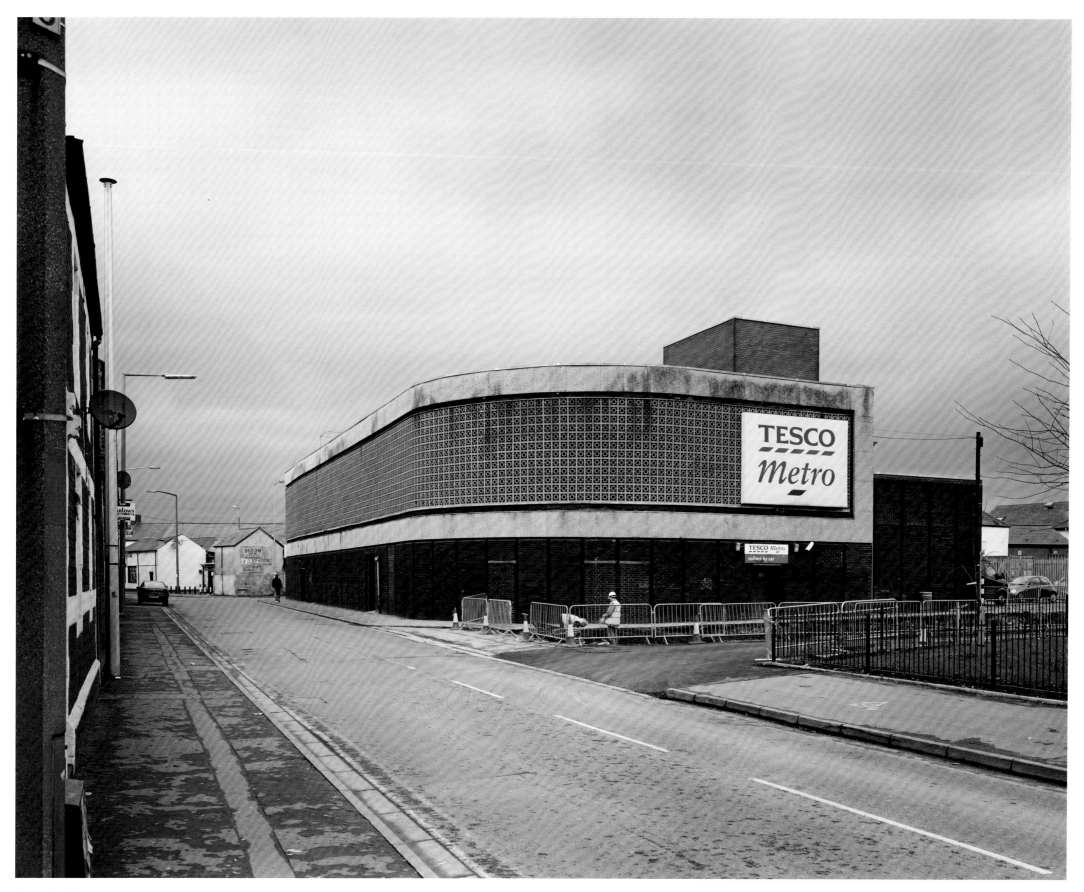

Canton, Cardiff

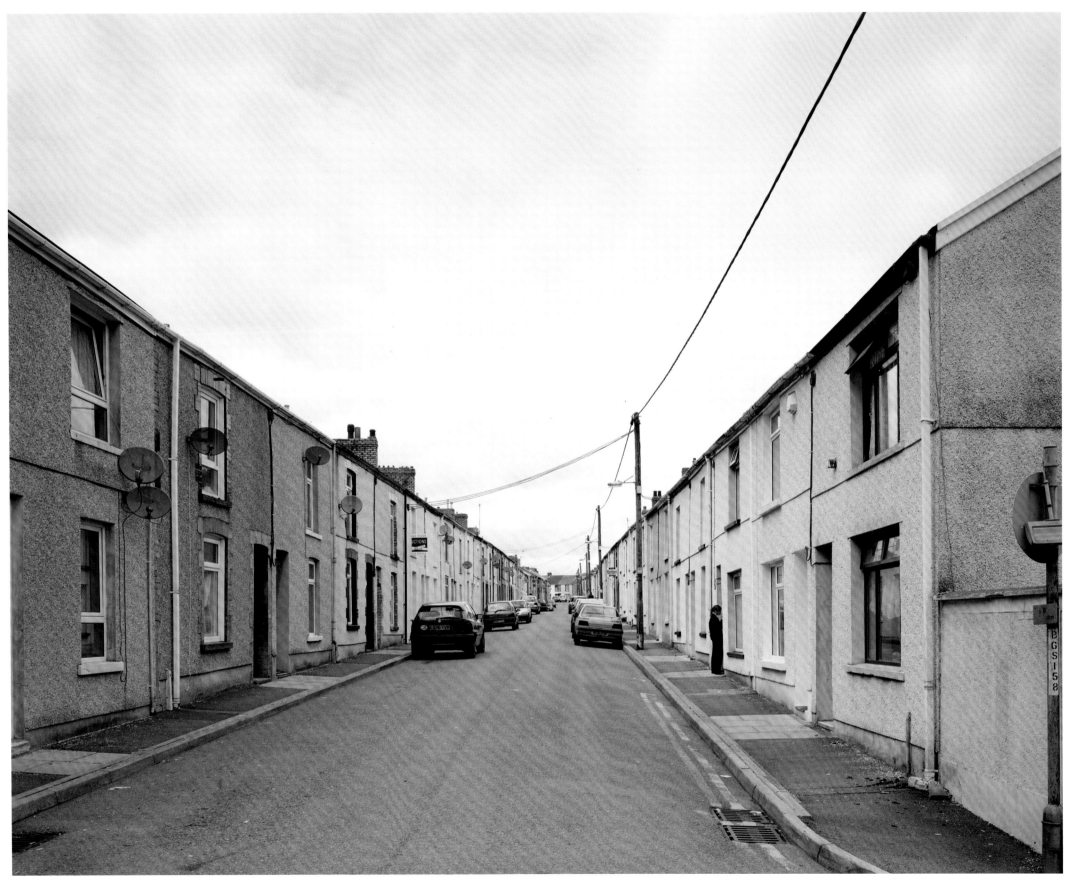

Ebbw Vale, Blaenau Gwent

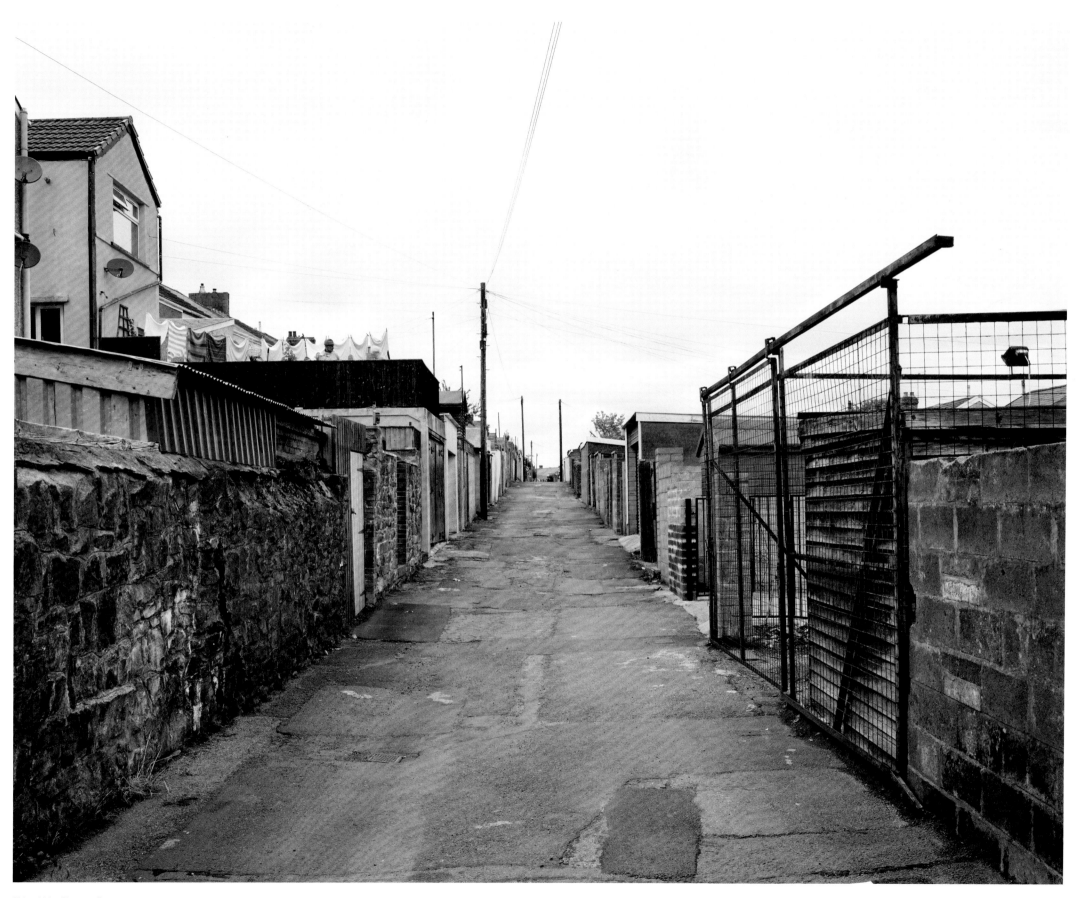

Ebbw Vale, Blaenau Gwent

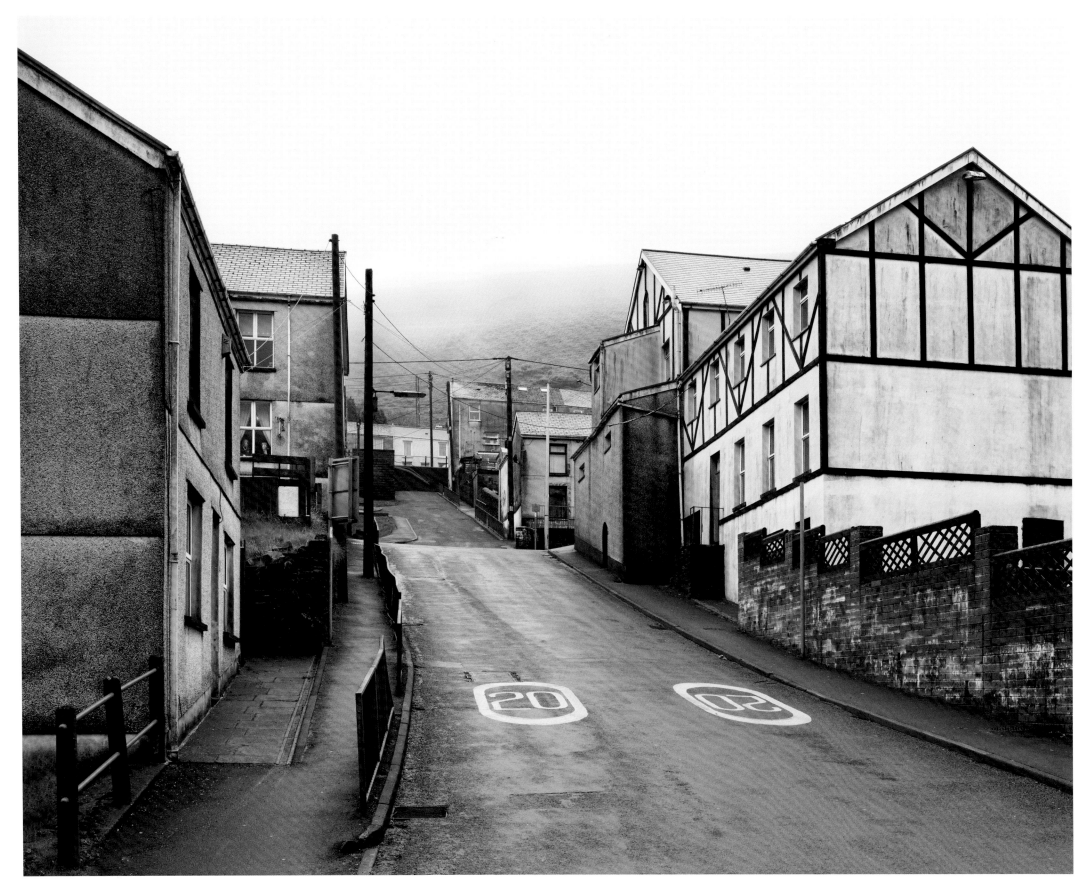

Blaengwynfi, Neath Port Talbot

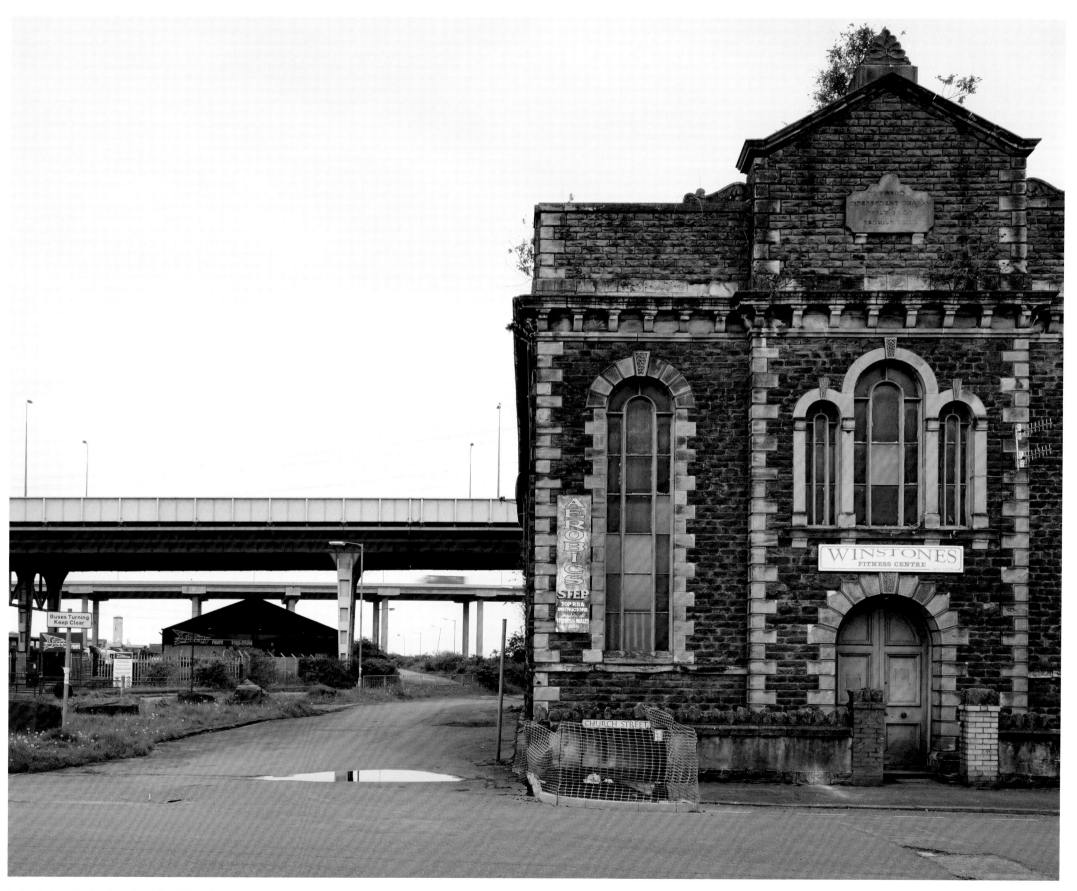

Bethesda Chapel, Briton Ferry, Neath Port Talbot

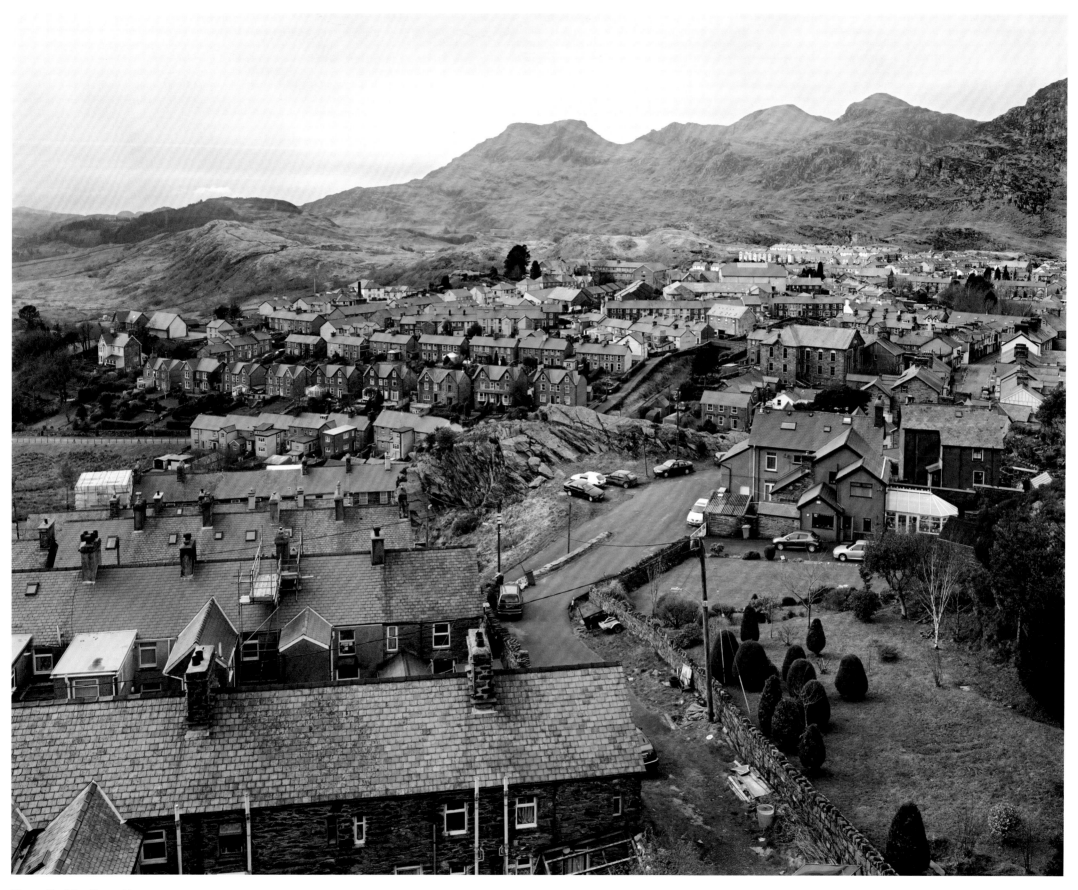

Blaenau Ffestiniog, Gwynedd

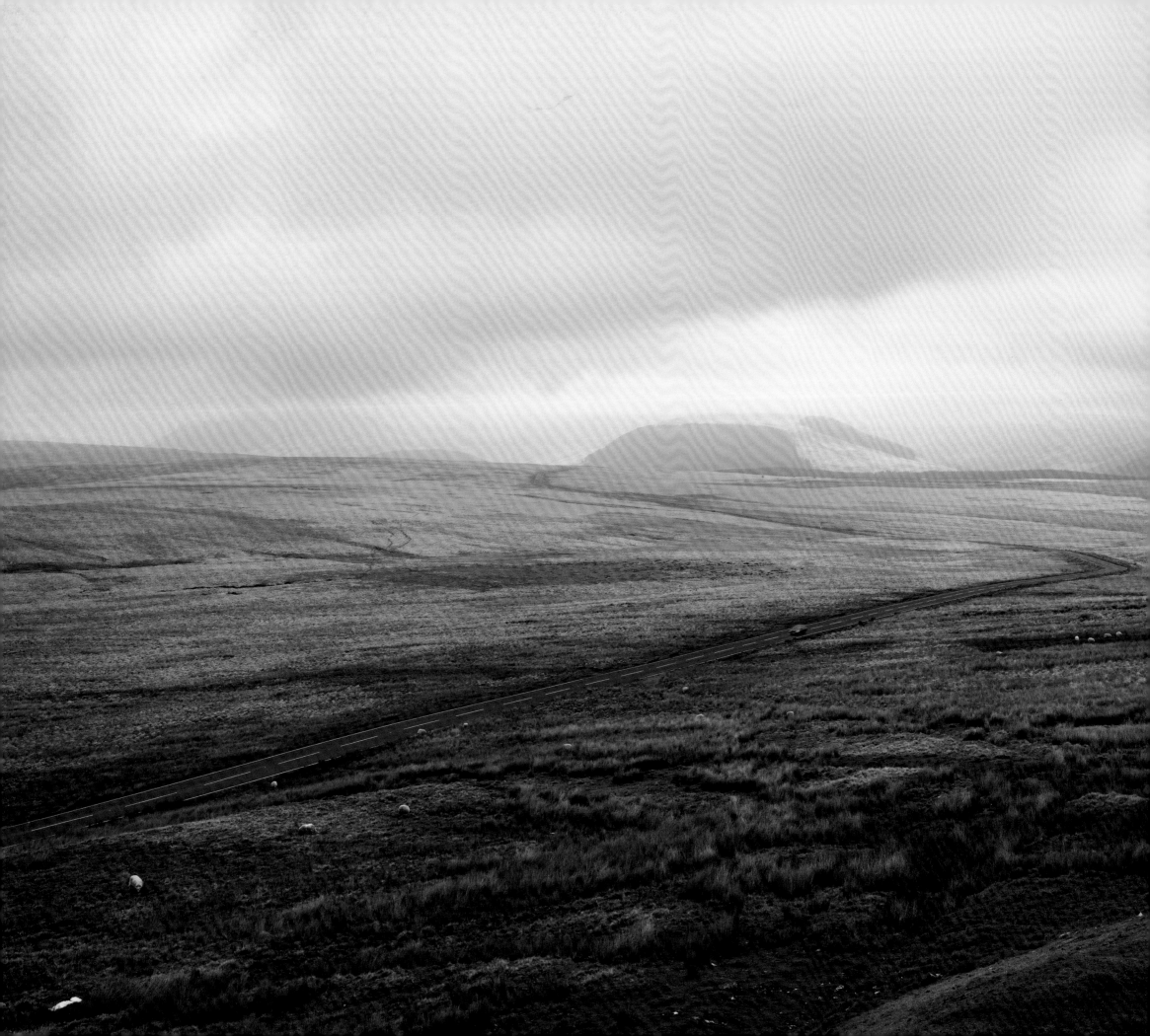

A4093 at Cefn Esgair, Carnau, Powys

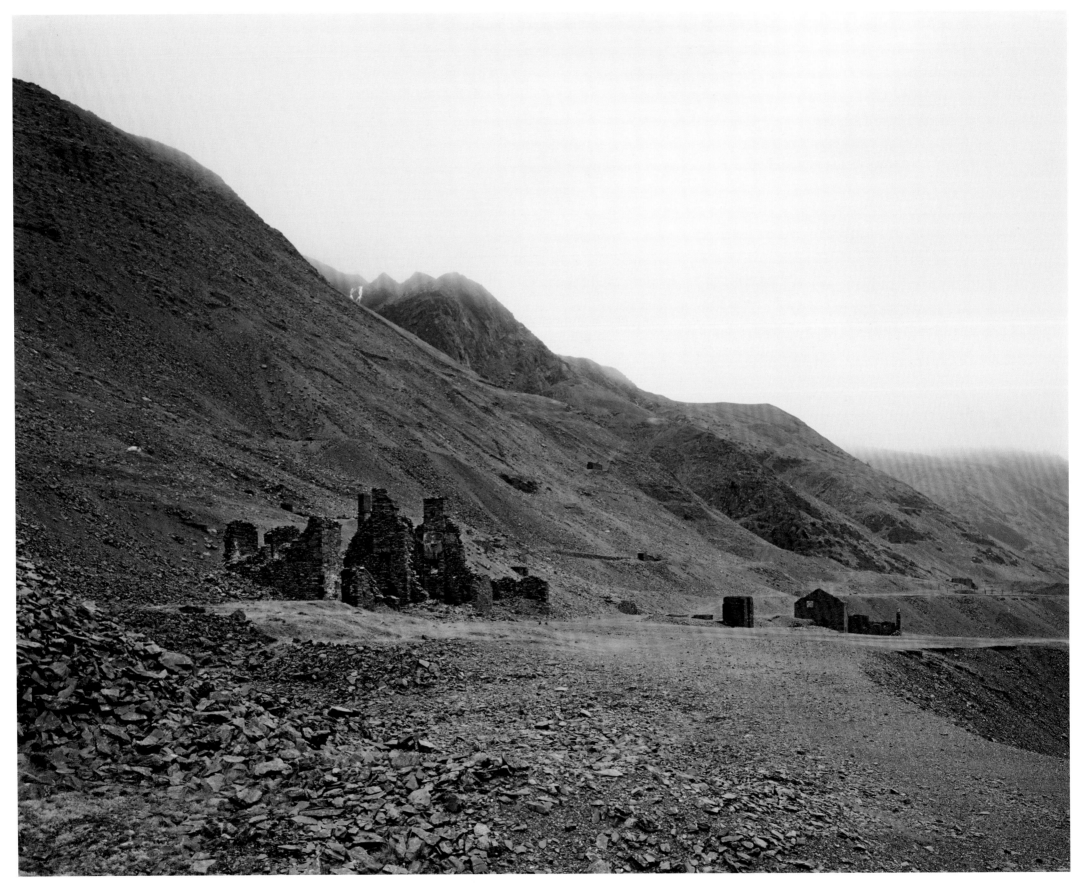

Leadmine (disused), Cwmystwyth, Ceredigion

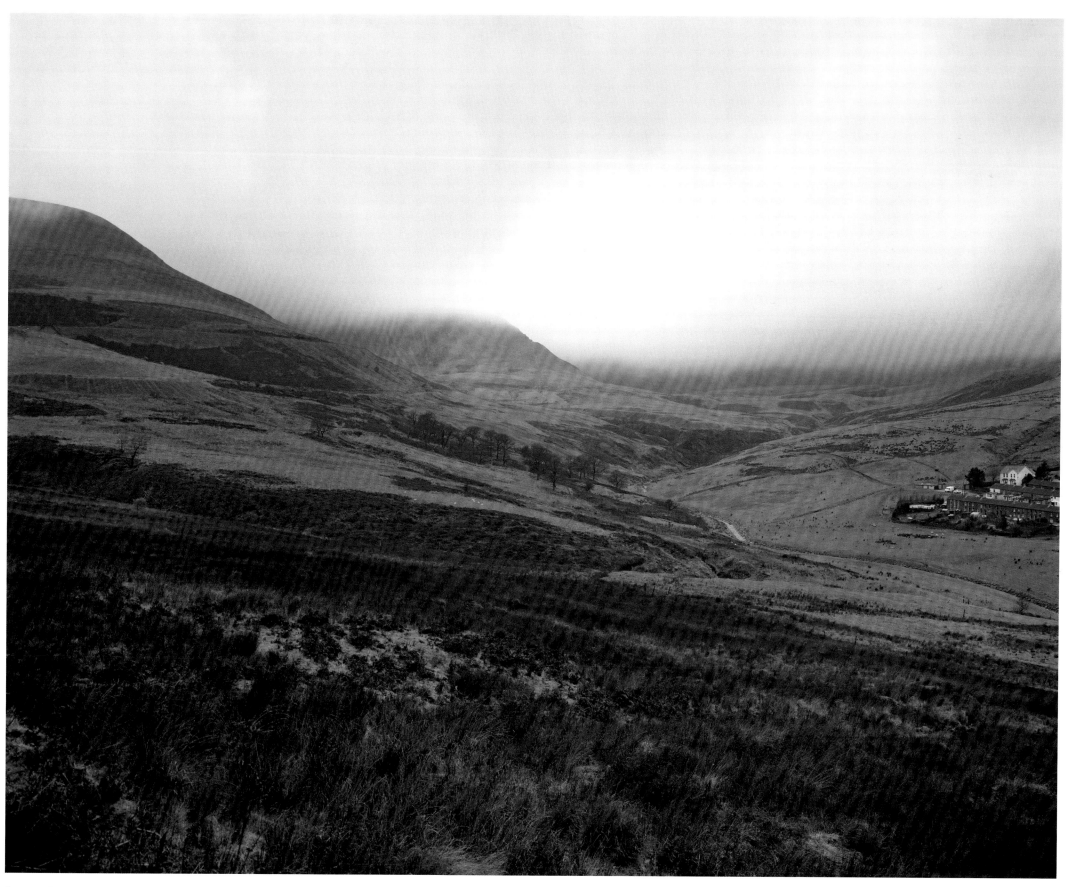

Cwmparc, Treorchy, Rhondda Fawr, Rhondda Cynon Taf

Llyn Fawr, nr. Rhigos, Rhondda Cynon Taff

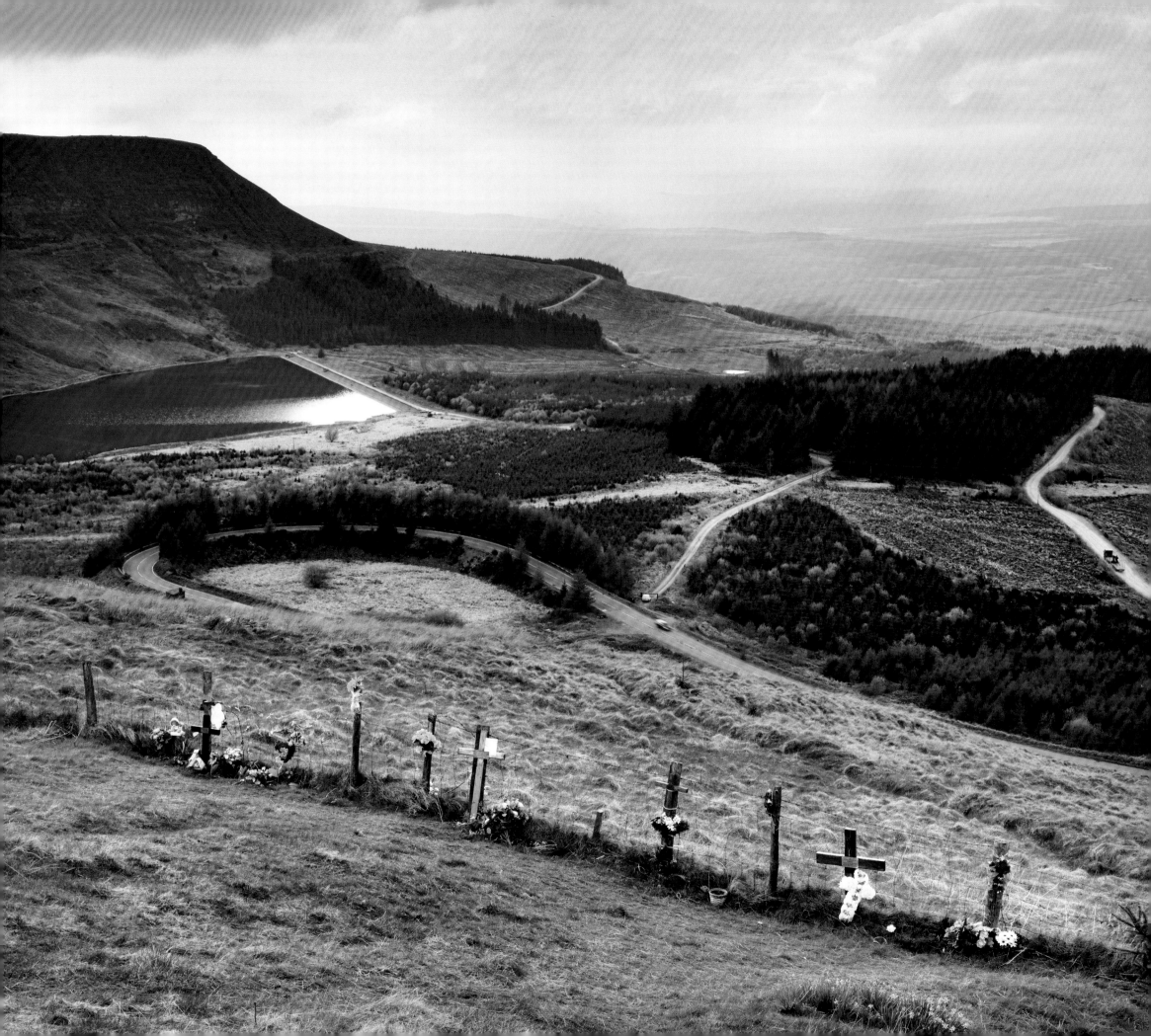

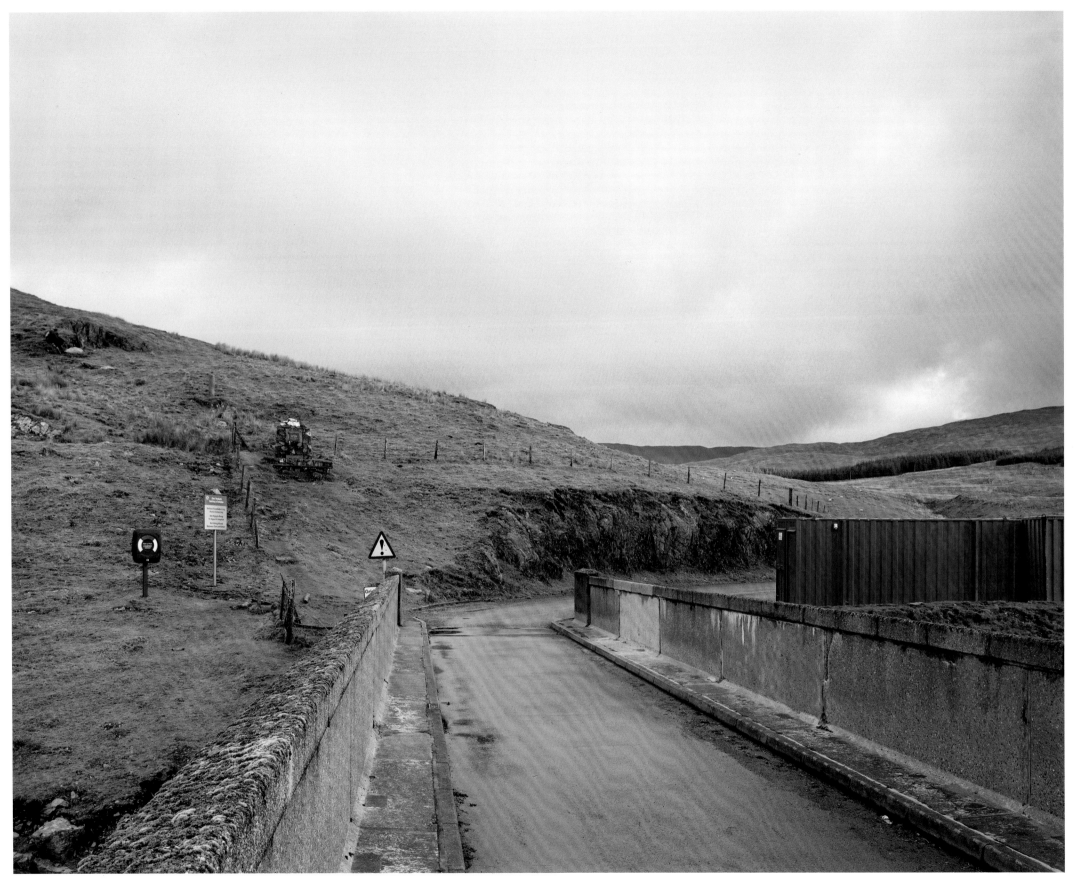

Memorial stone to Owen Glendwr's victory at the Battle of Mynydd Hyddgen, Nant y Moch, Ceredigion

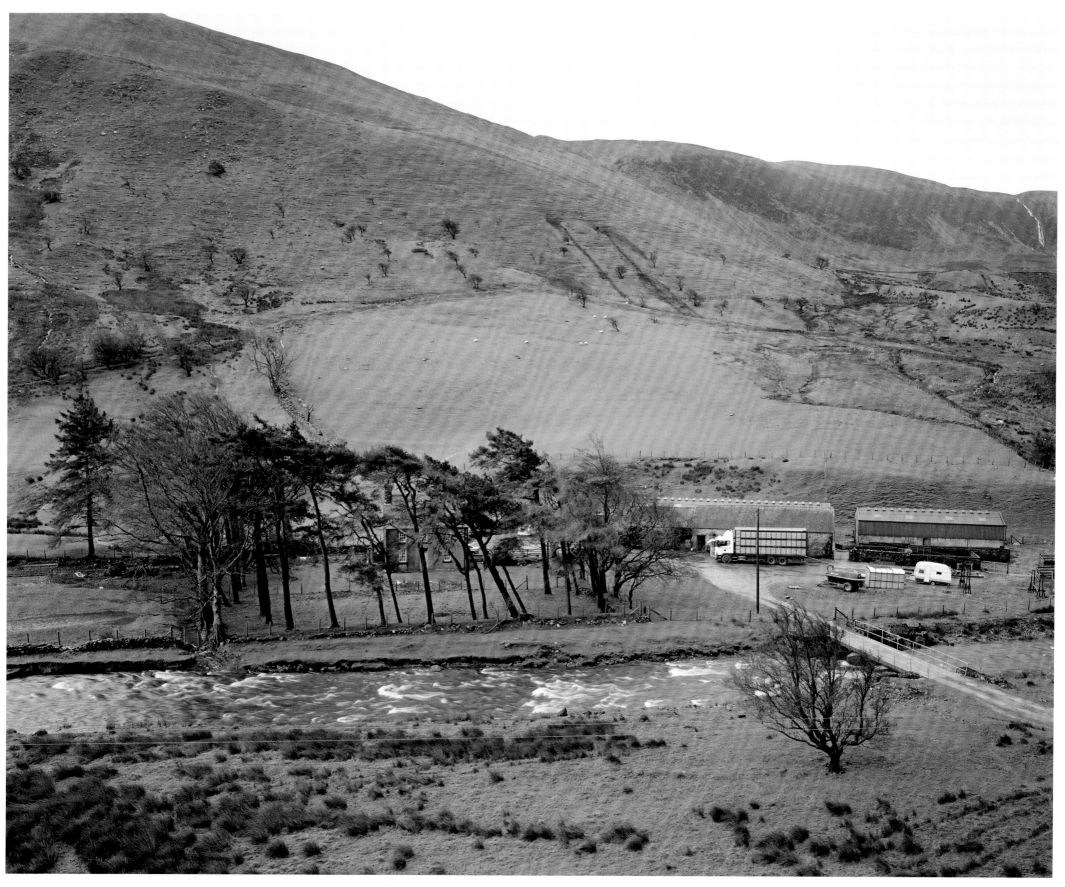

Farm, Cwmystwyth, Ceredigion

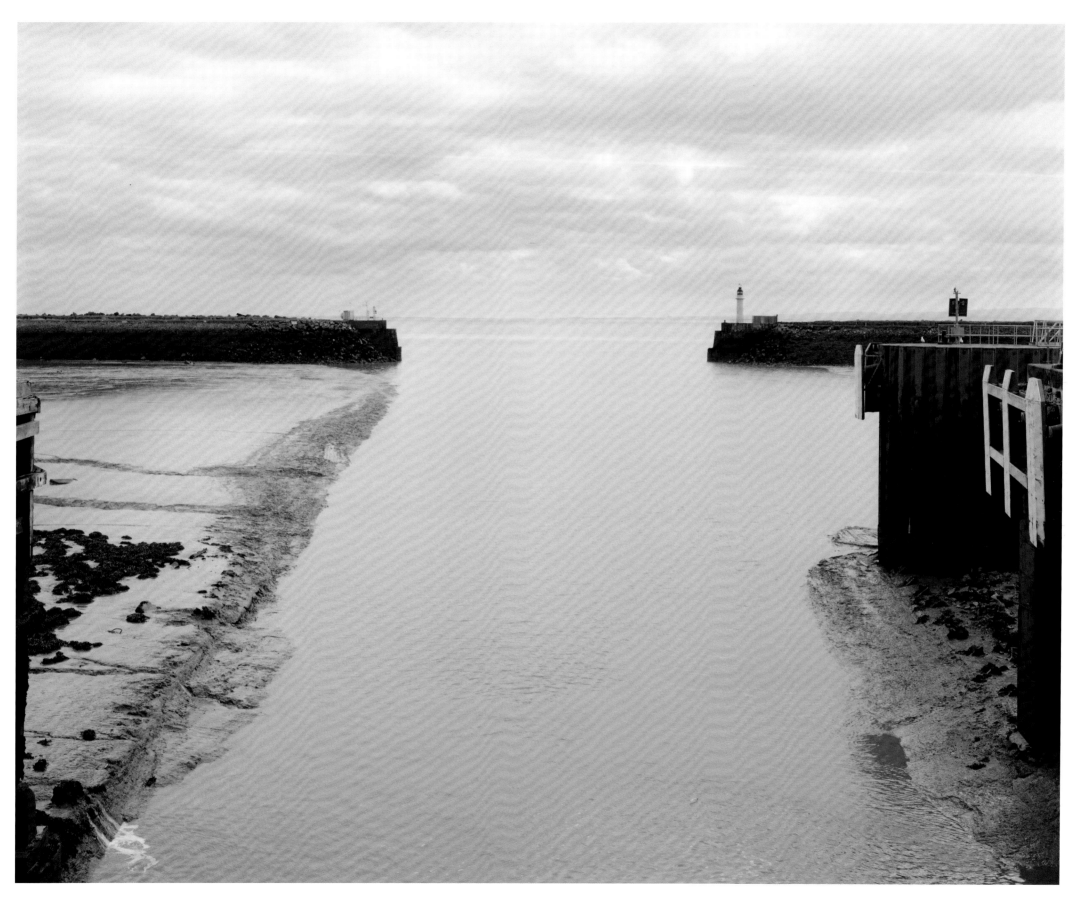

Barry Docks, Vale of Glamorgan

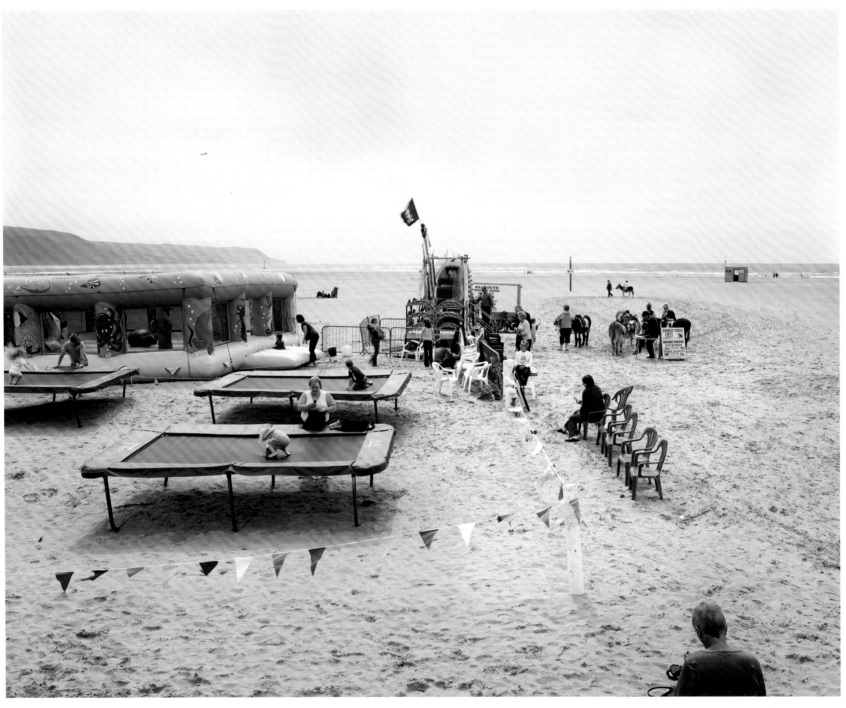

Barmouth beach, Gwynedd

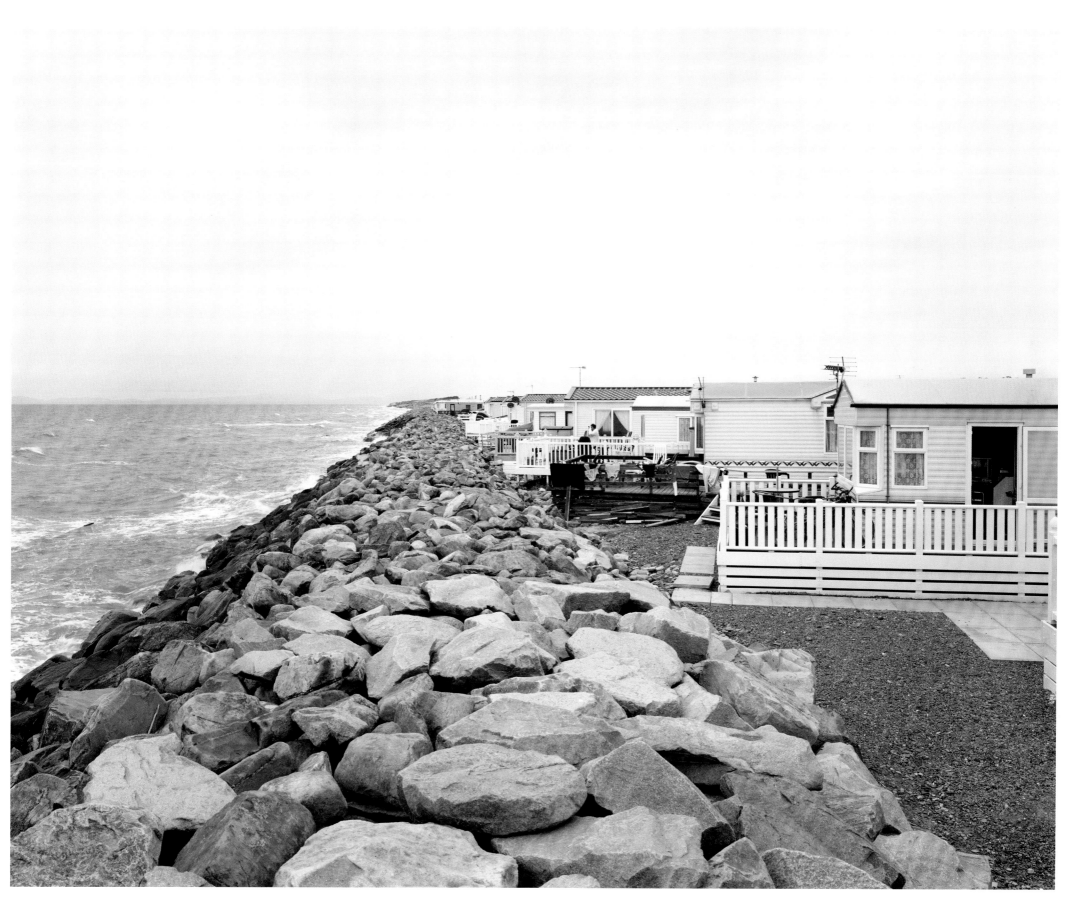

Sunnysands Caravan Park, Gwynedd

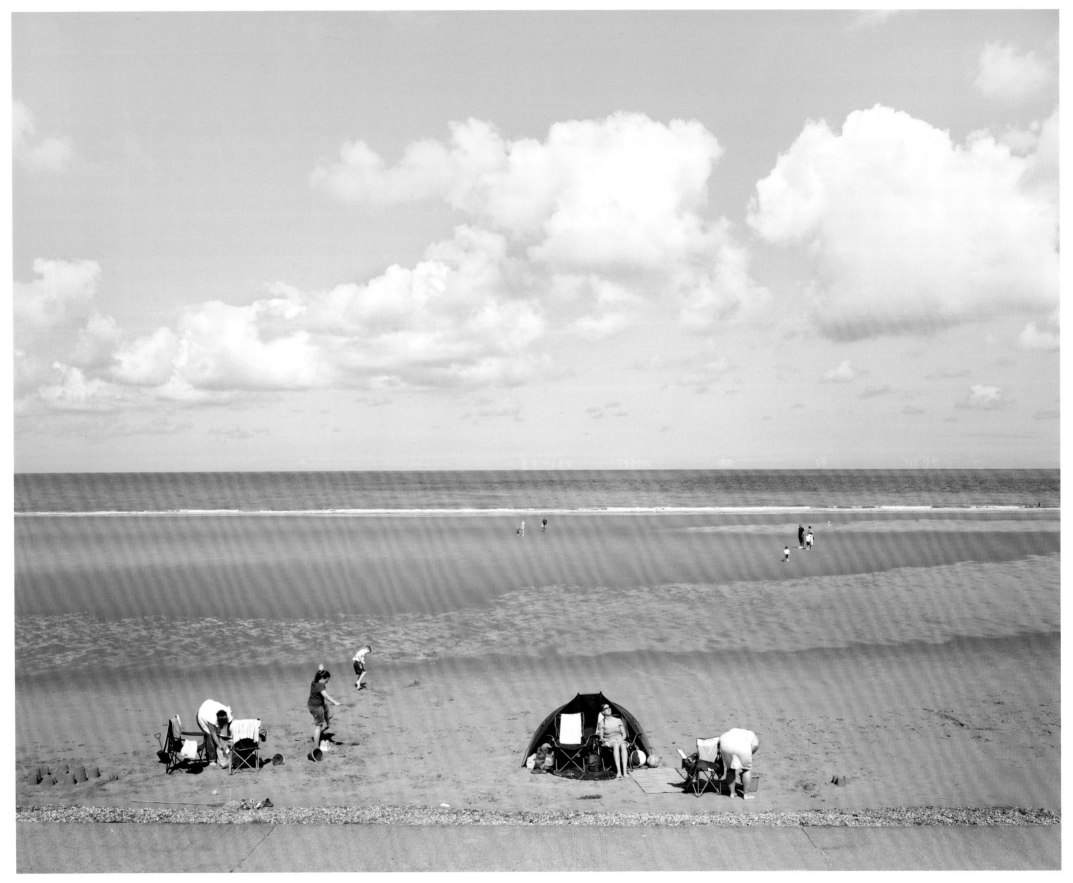

Prestatyn beach, Denbighshire

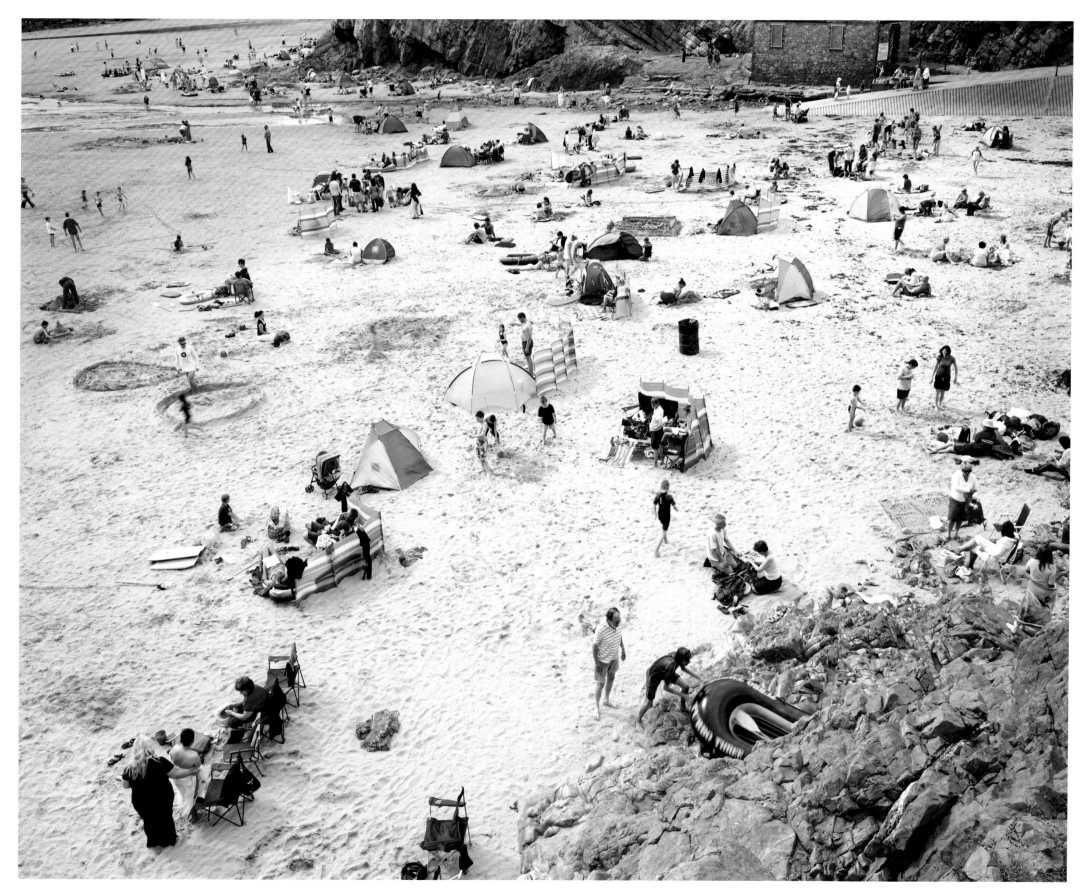

Caswell Bay, Gower, Swansea

Cadoxton, Barry, Vale of Glamorgan

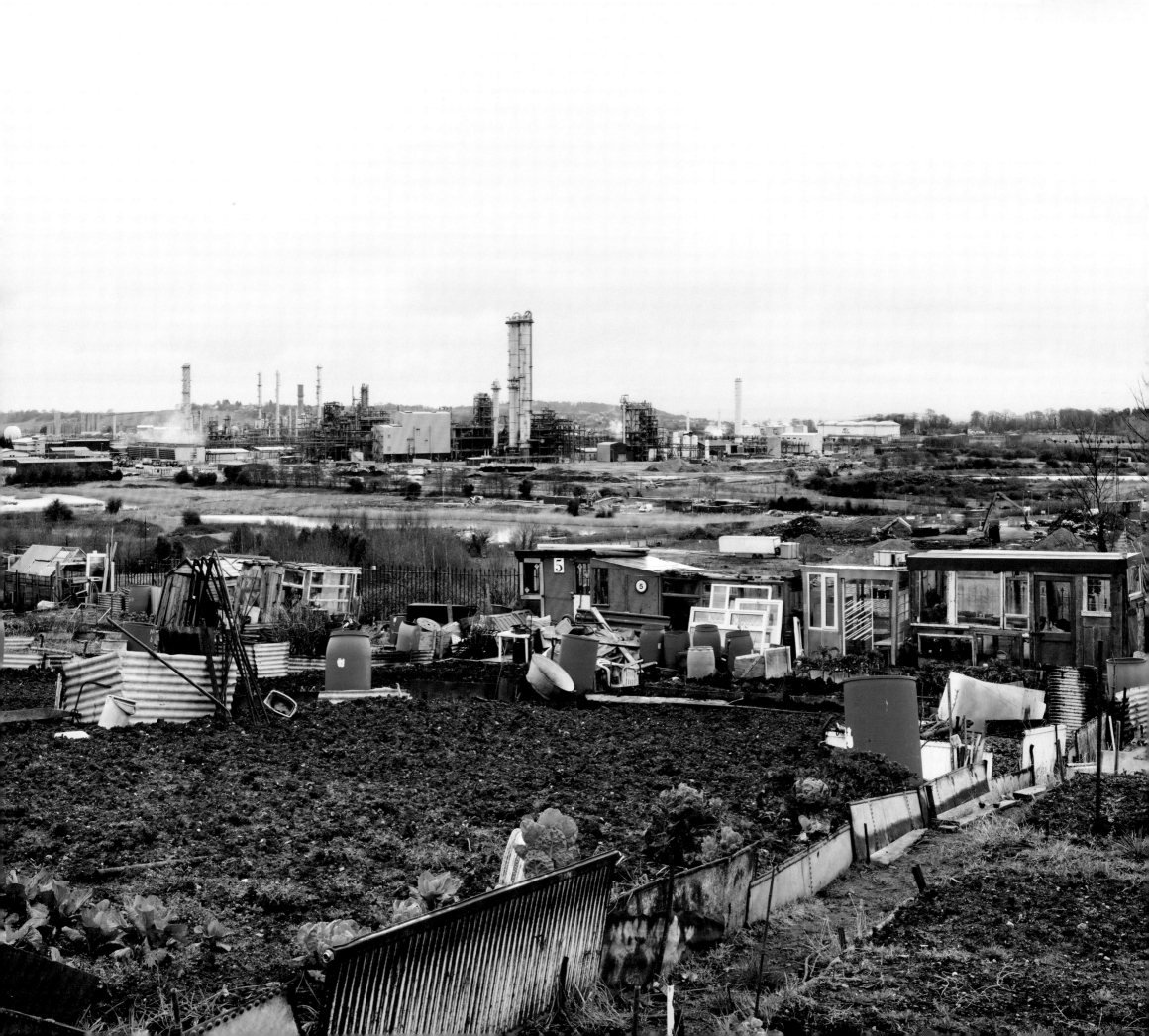

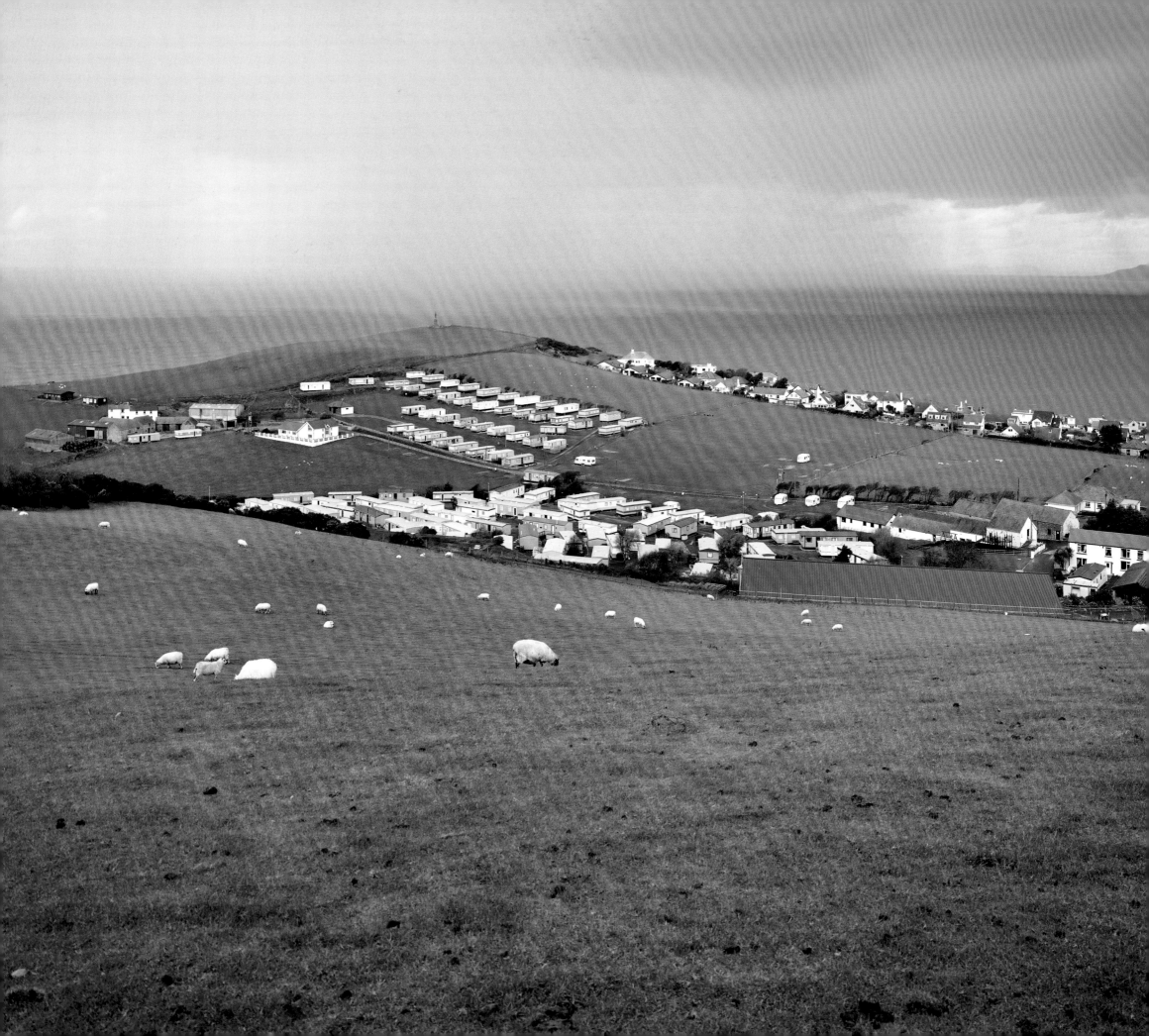

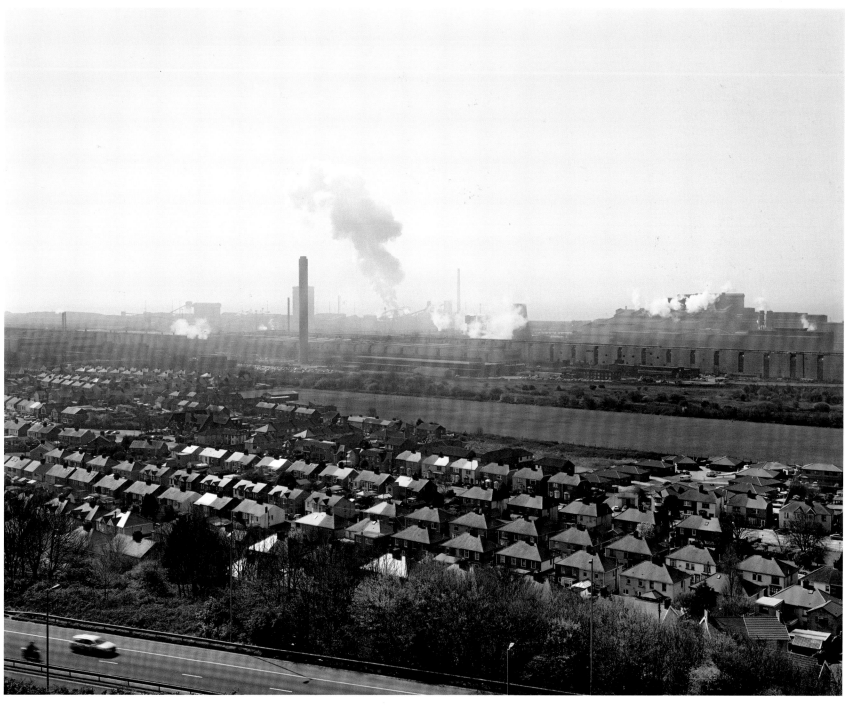

Borth, Ceredigion / Margam, Neath Port Talbot

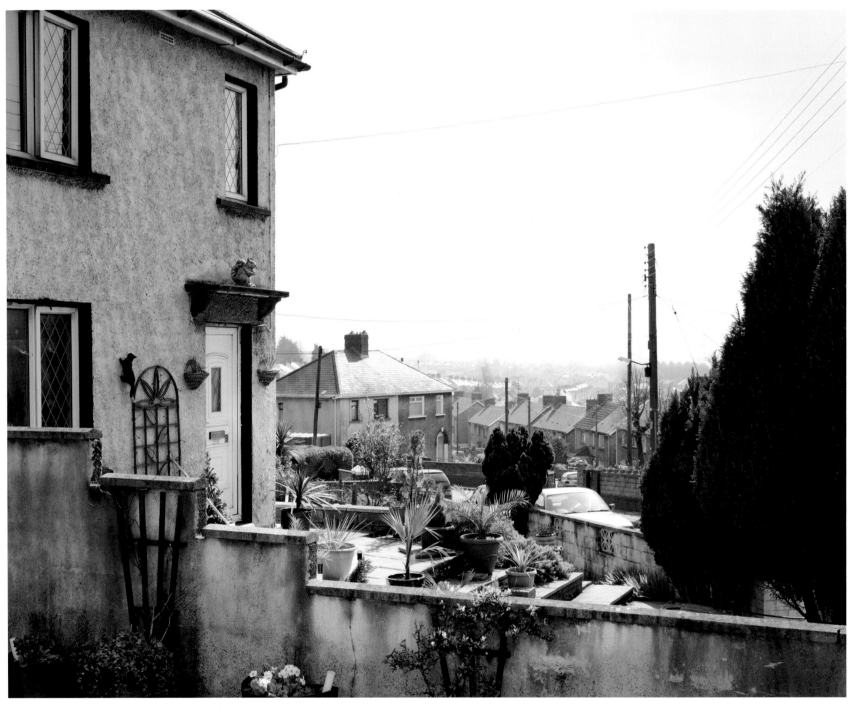

Margam, Neath Port Talbot

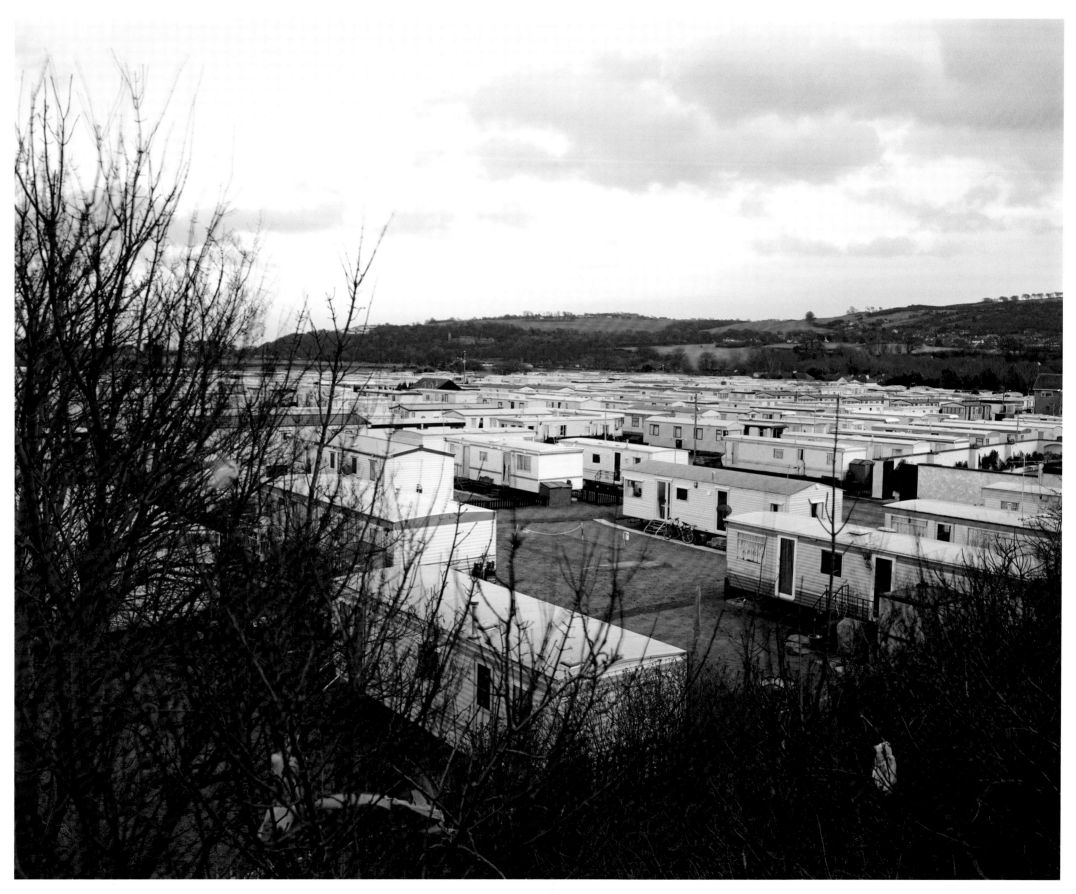

Greenacres Caravan Park, Gronant, Denbighshire

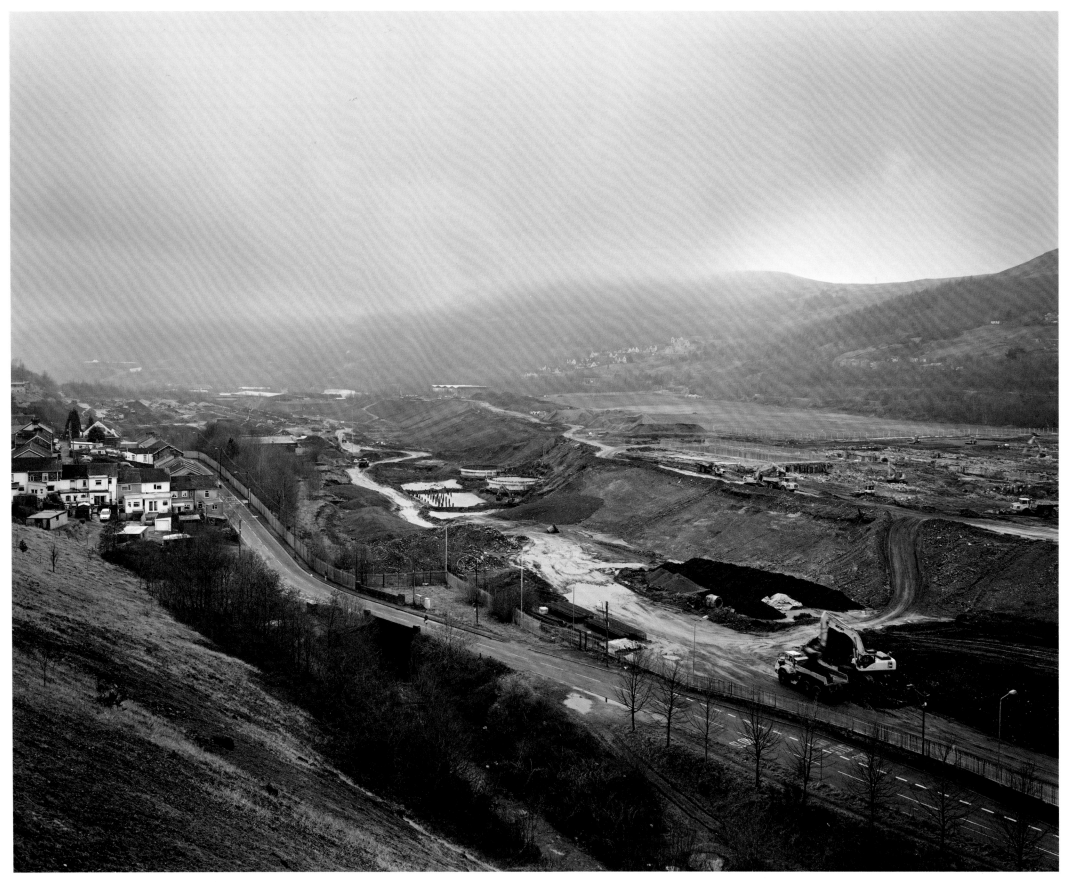

Old Steelworks, Ebbw Vale, Blaenau Gwent

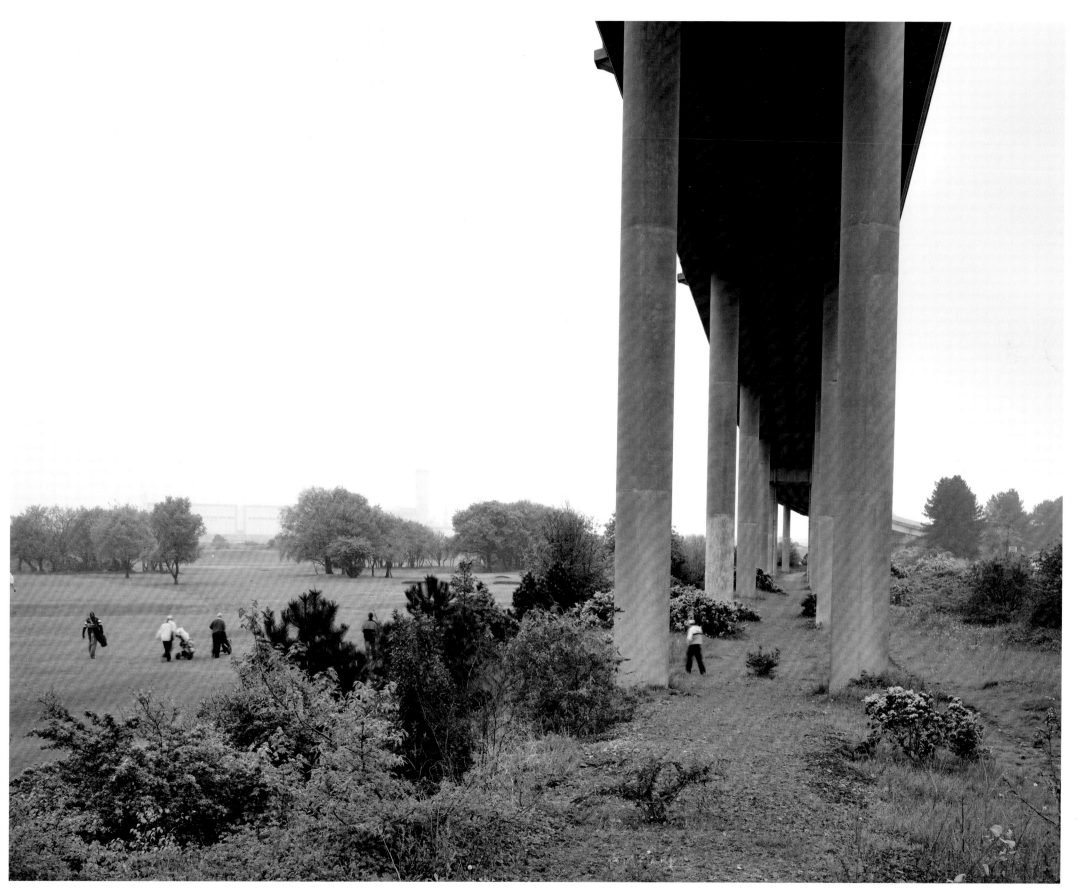

Earlswood Golf Club, Jersey Marine, Neath Port Talbot

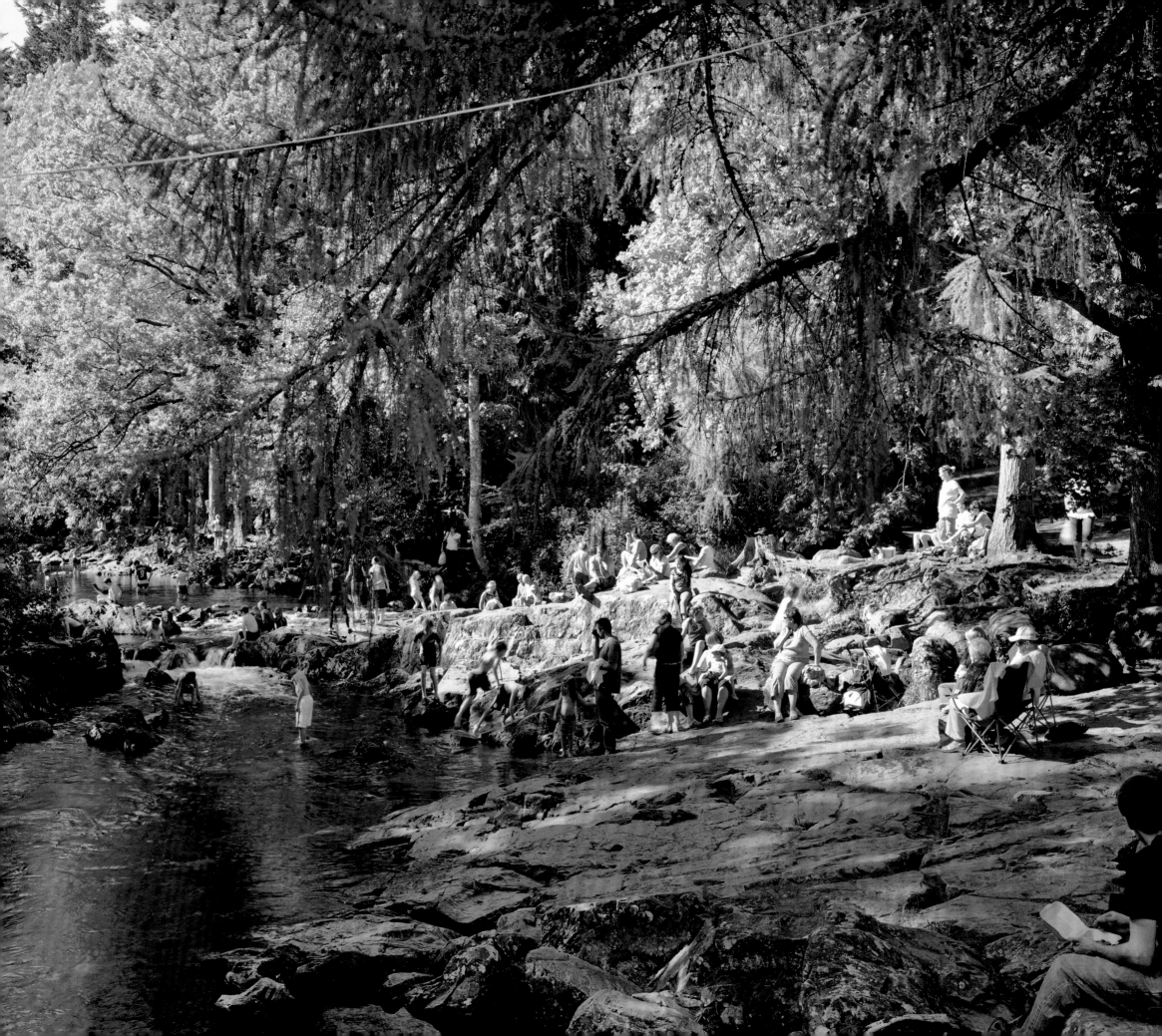

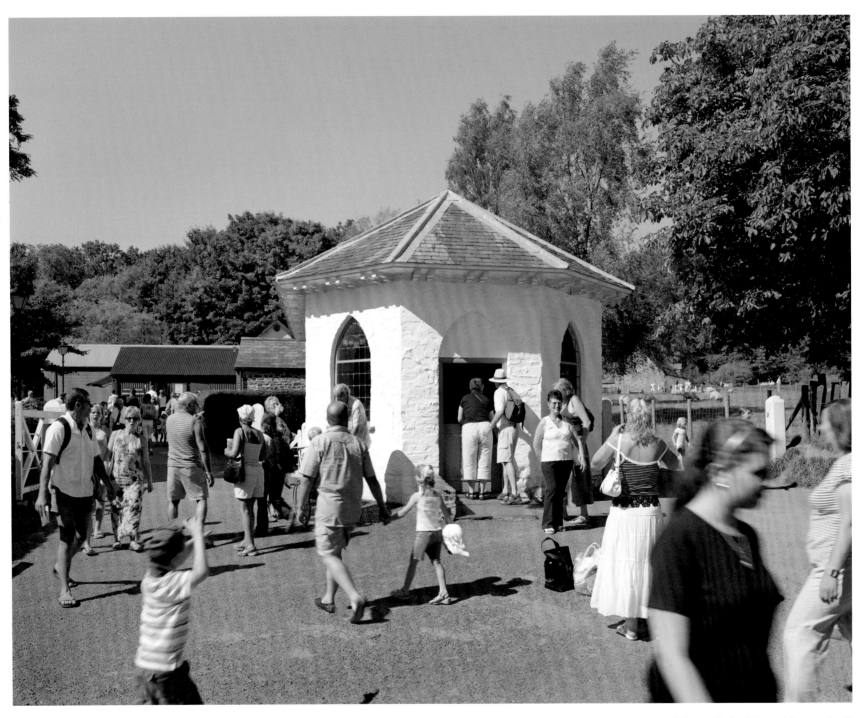

Toll house, St Fagans National History Museum, Cardiff

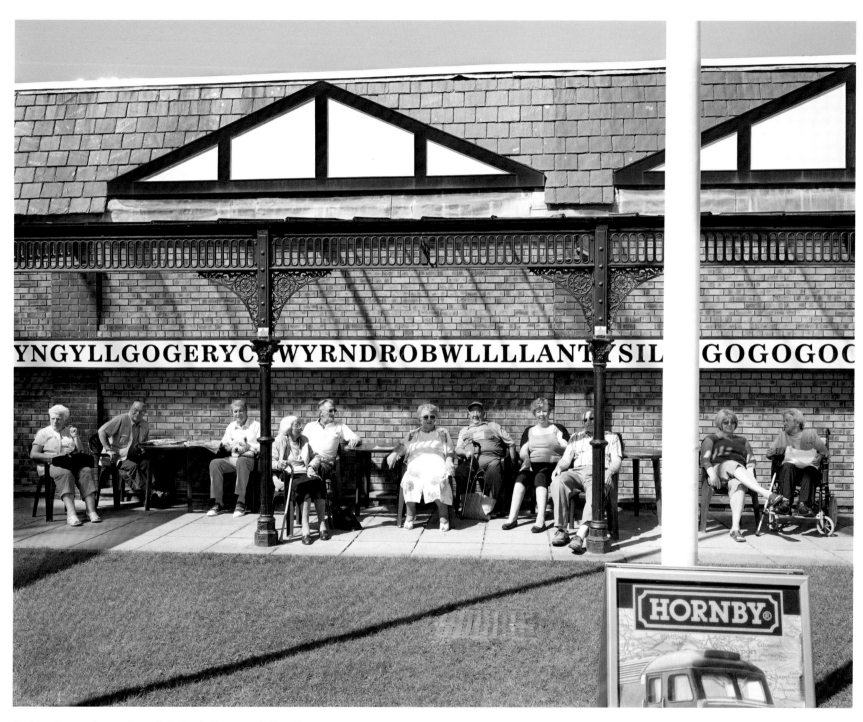

Llanfairpwllgwyngyllgogerychwyrndrobwllllantysiliogogogoch, Ynys Mon

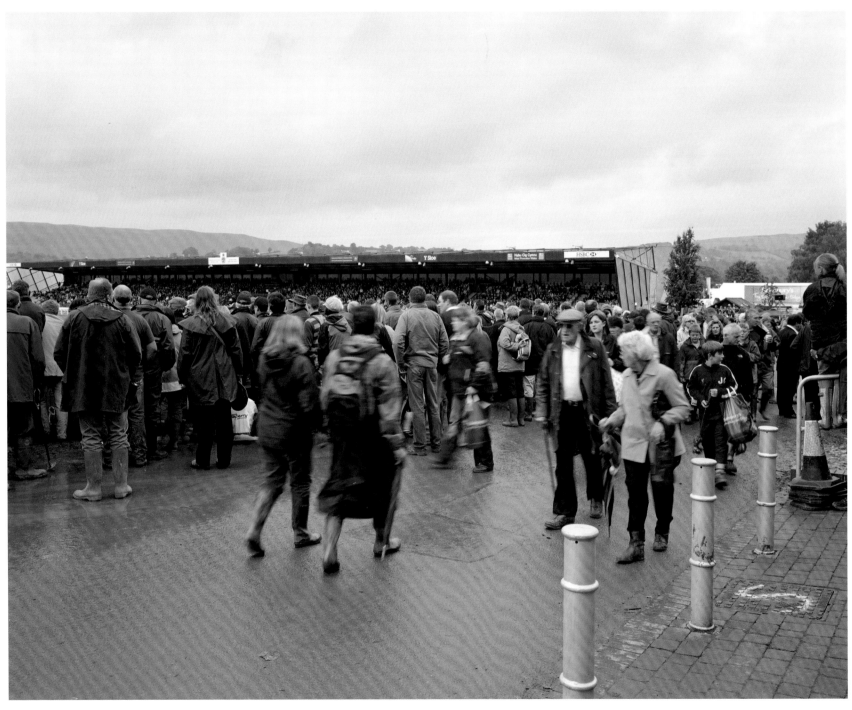

Royal Welsh Agricultural Show. Builth Wells, Powys

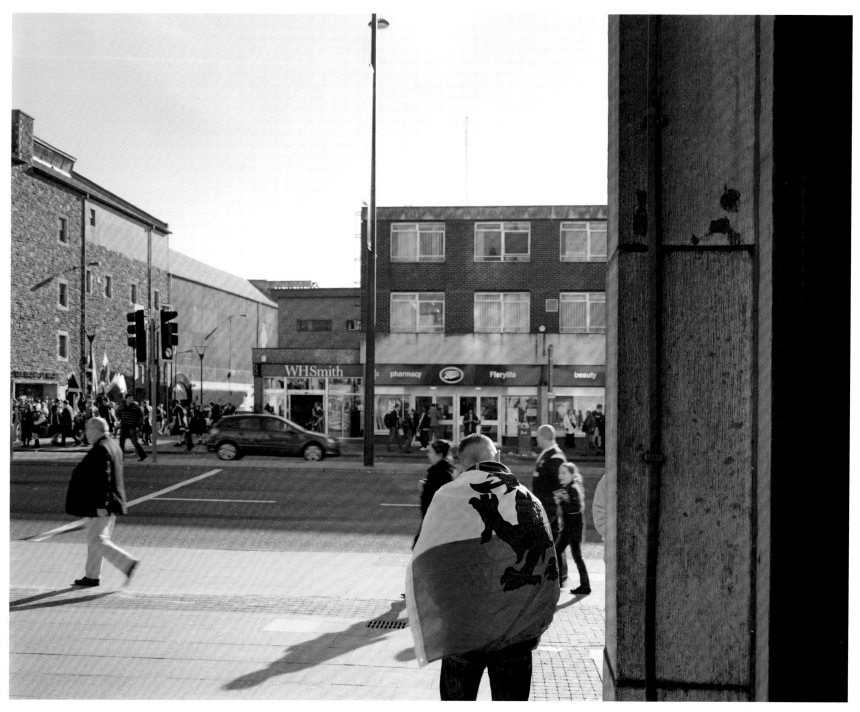

Wood Street, Cardiff

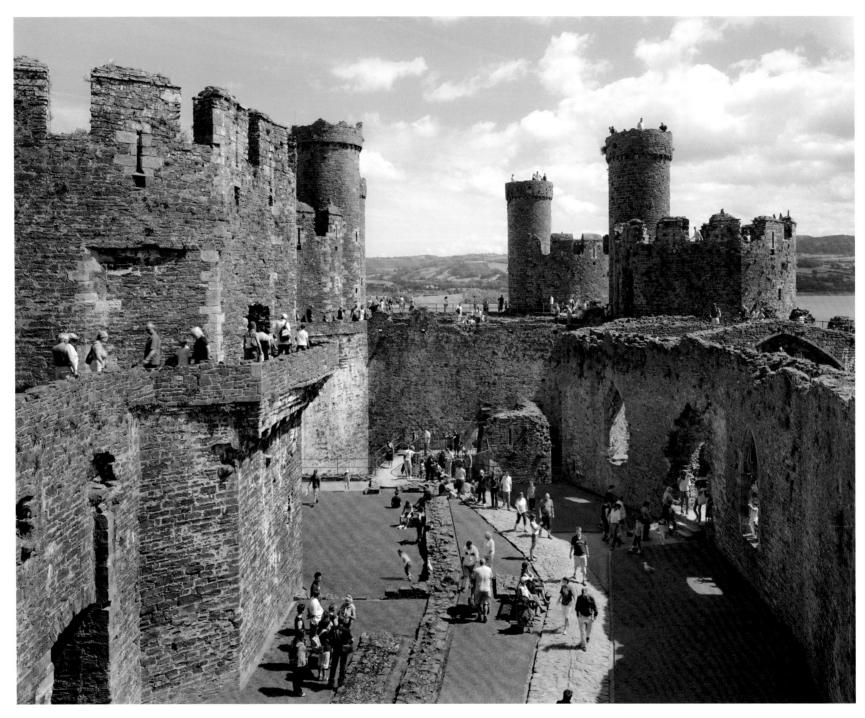

Conwy Castle, Conwy, Gwynedd / Dyfatty Flats, Swansea

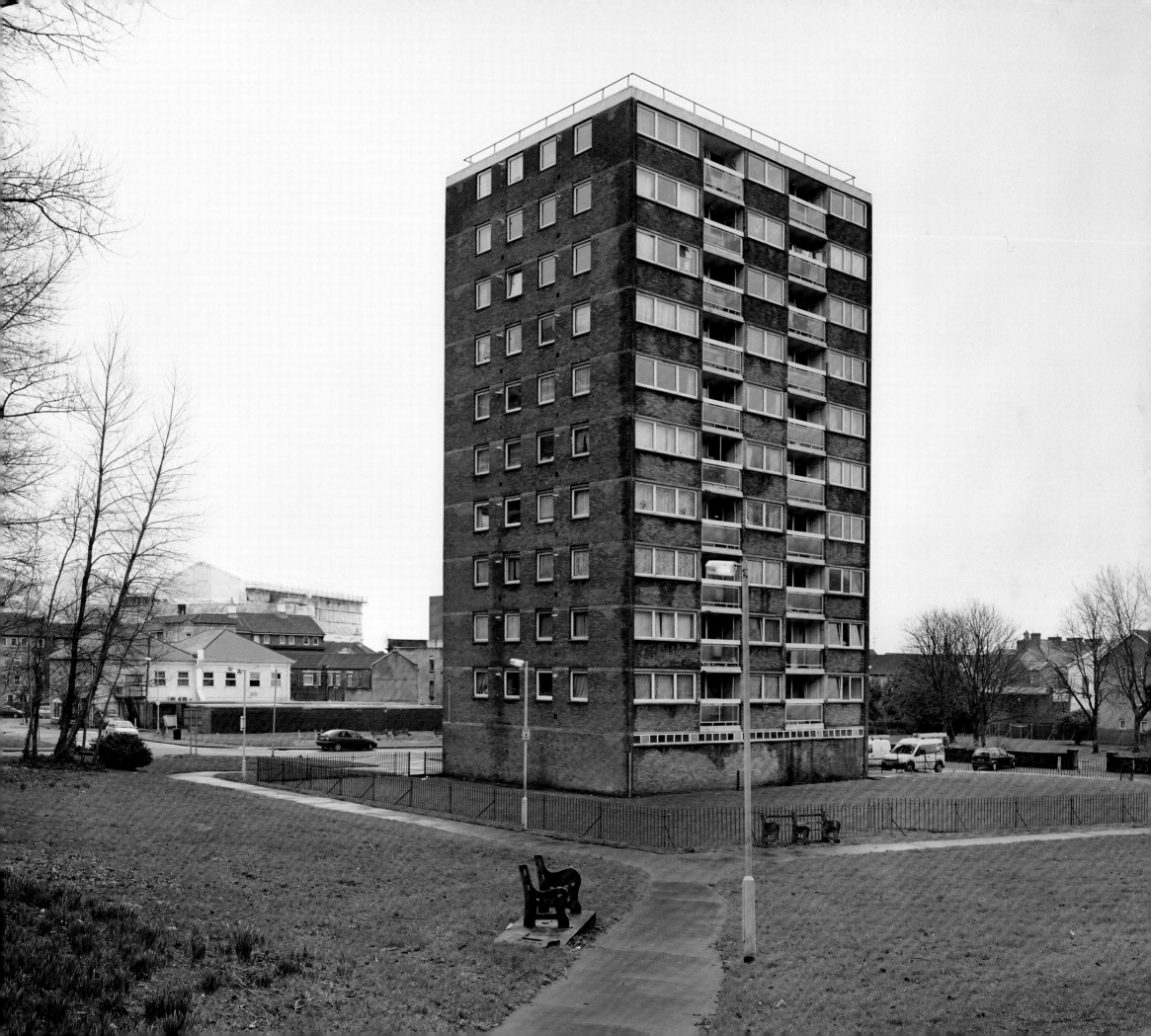

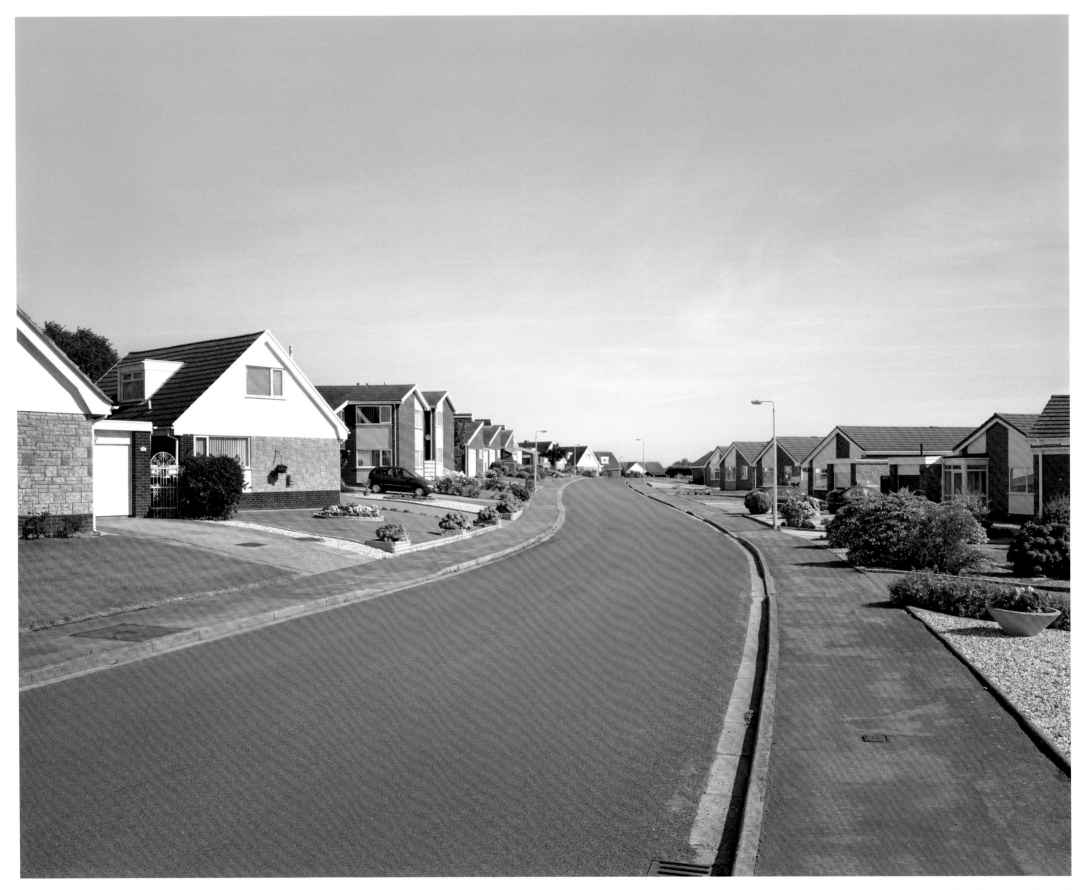

Penrhyn Beach West, Penrhyn Bay, Gwynedd

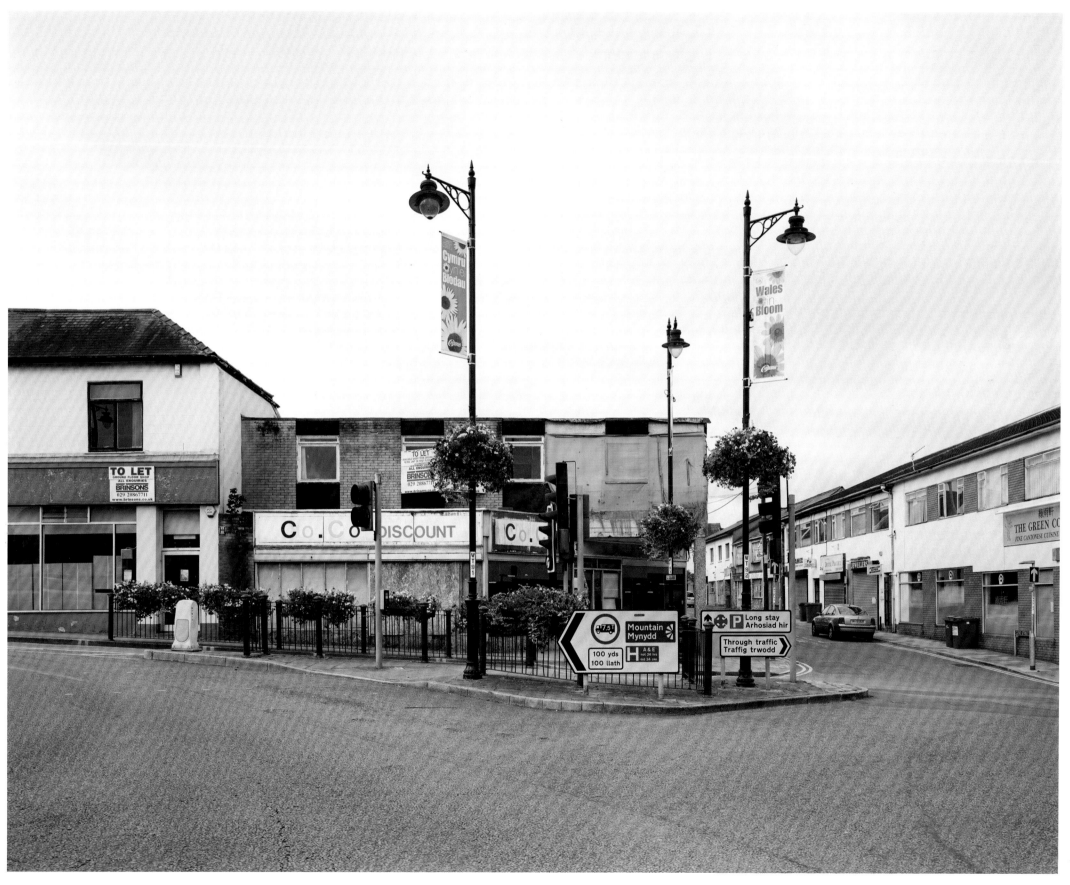

Caerffili

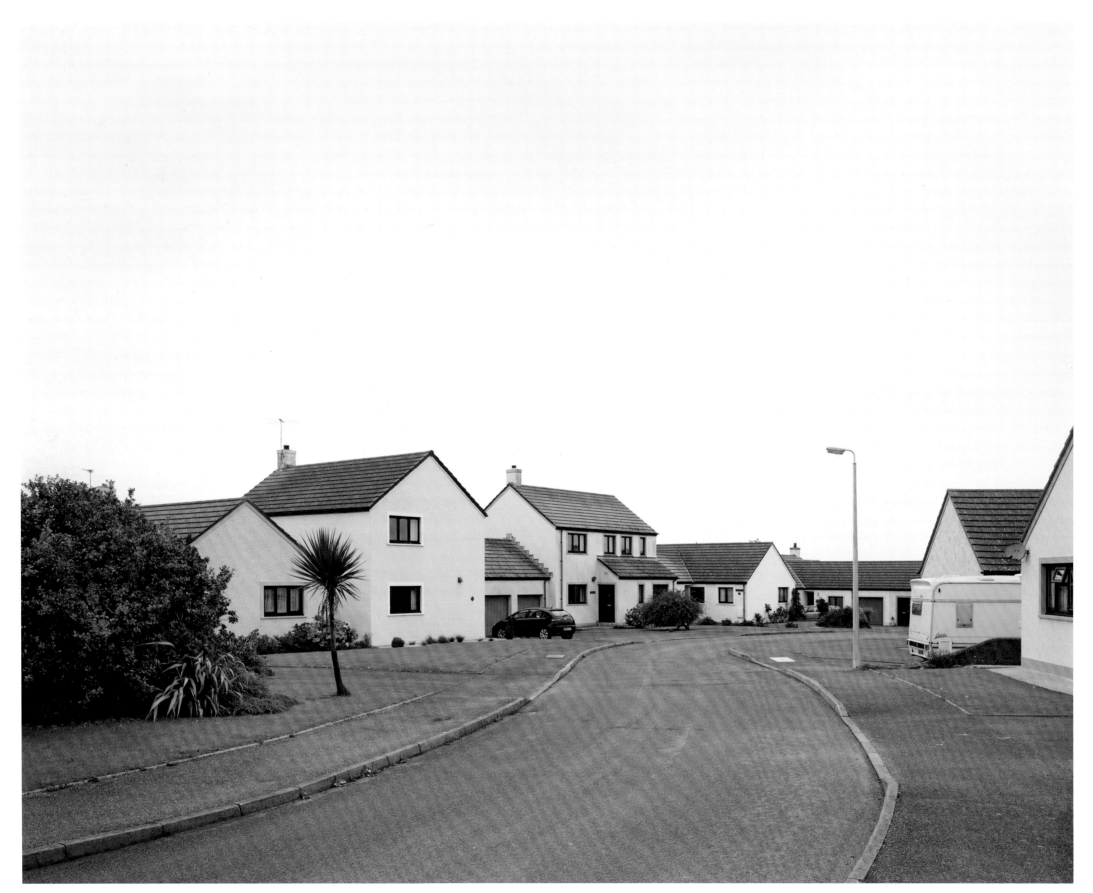

St David's, Pembrokeshire

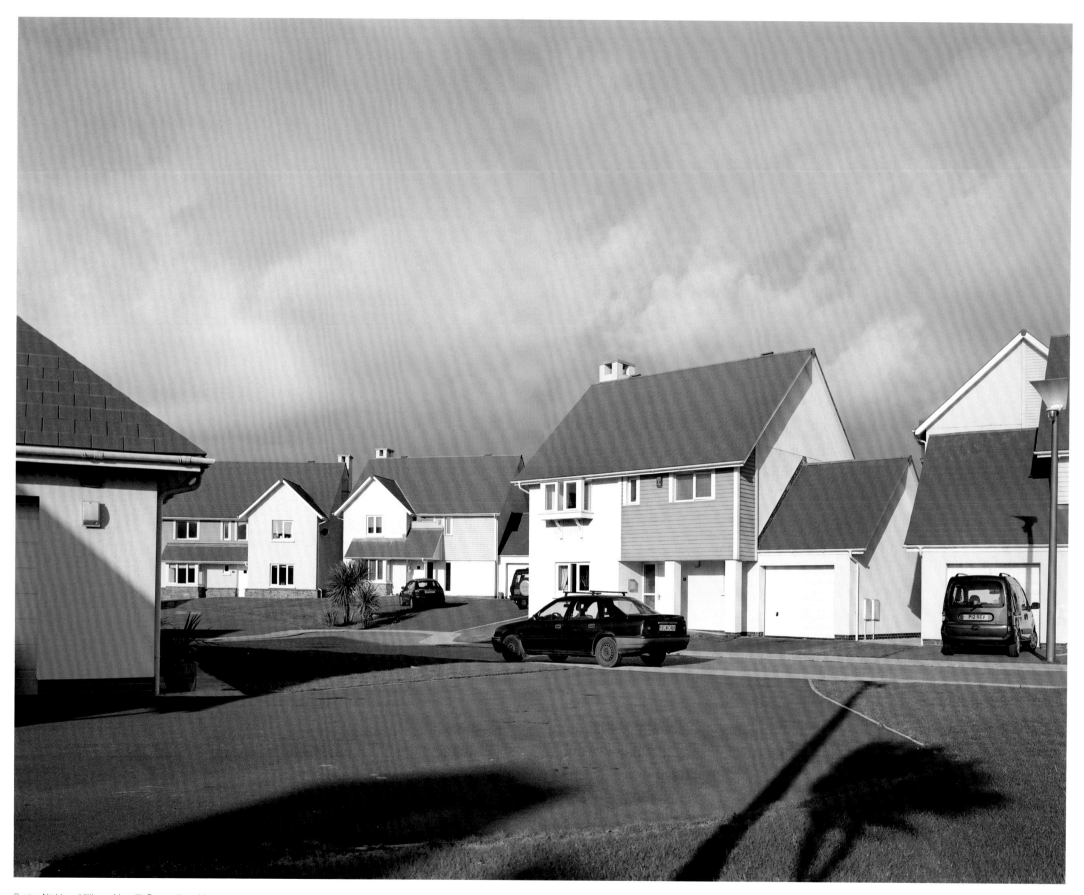

Pentre Nicklaus Villlage, Llanelli, Carmarthenshire

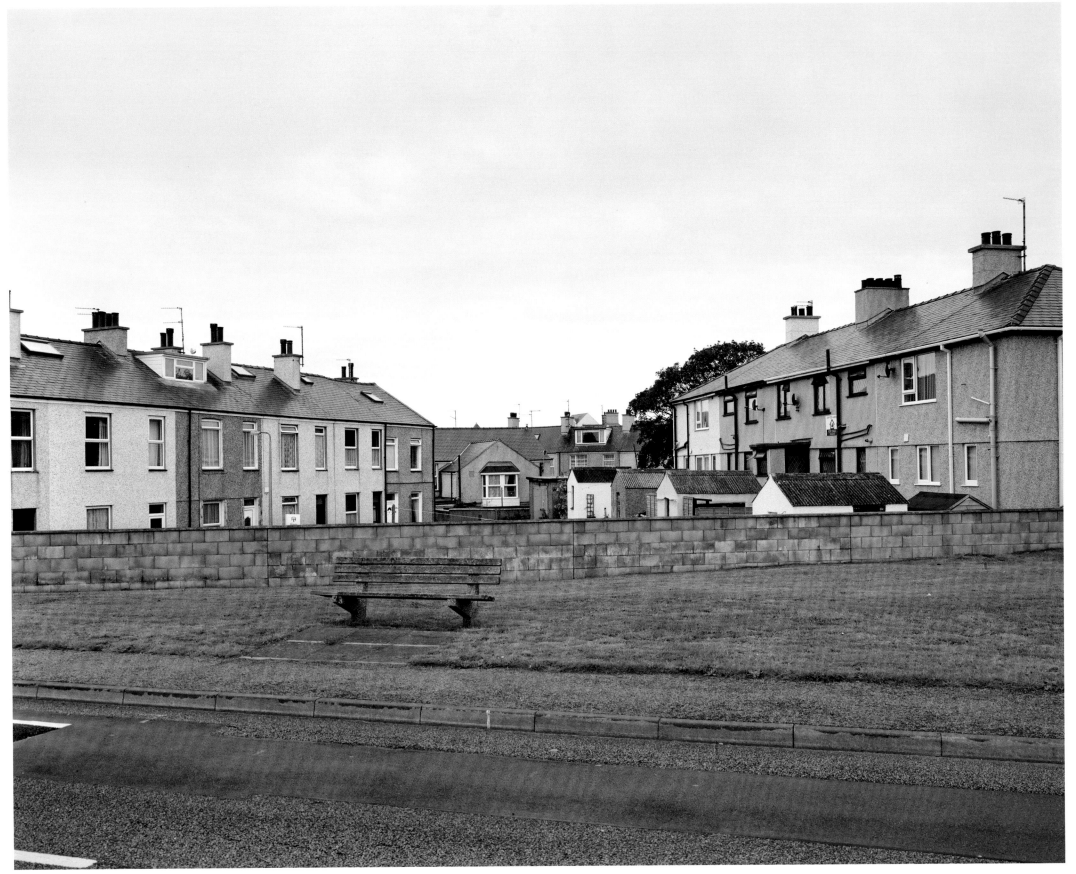

Holyhead, Ynys Mon

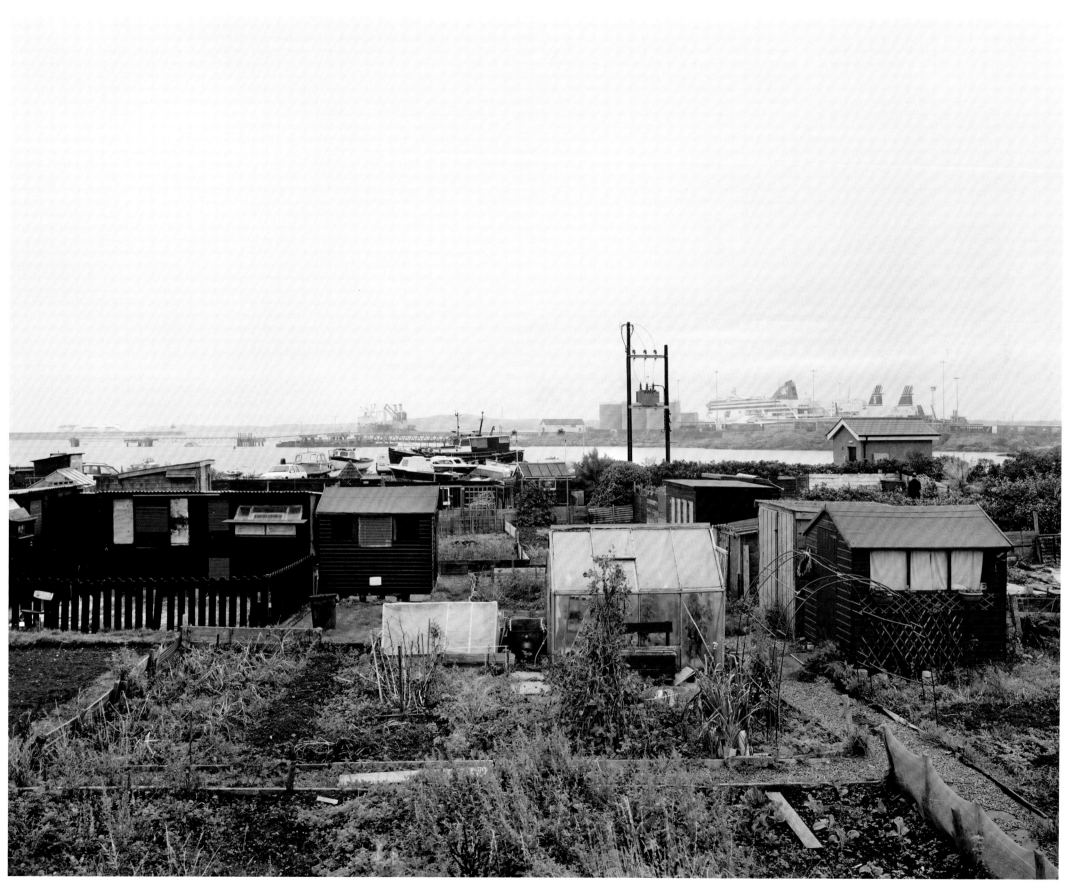

Holyhead, Ynys Mon

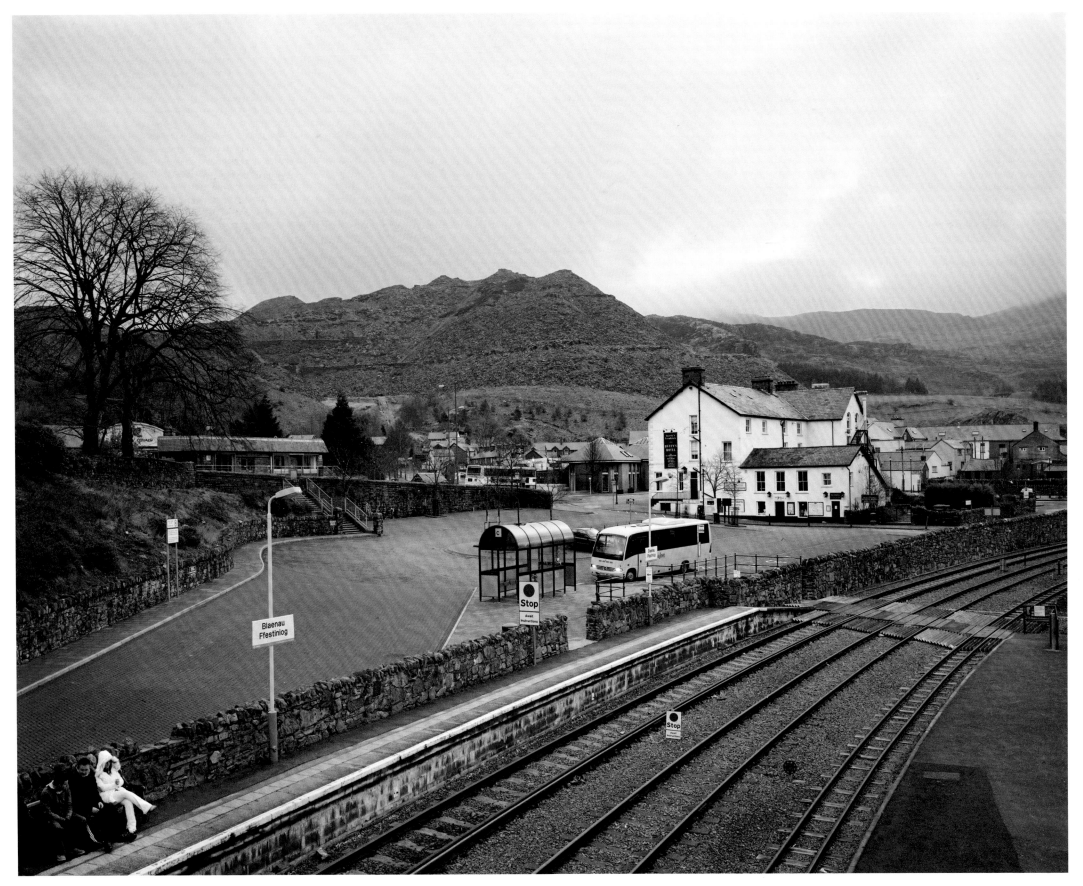

Blaenau Ffestiniog, Gwynedd

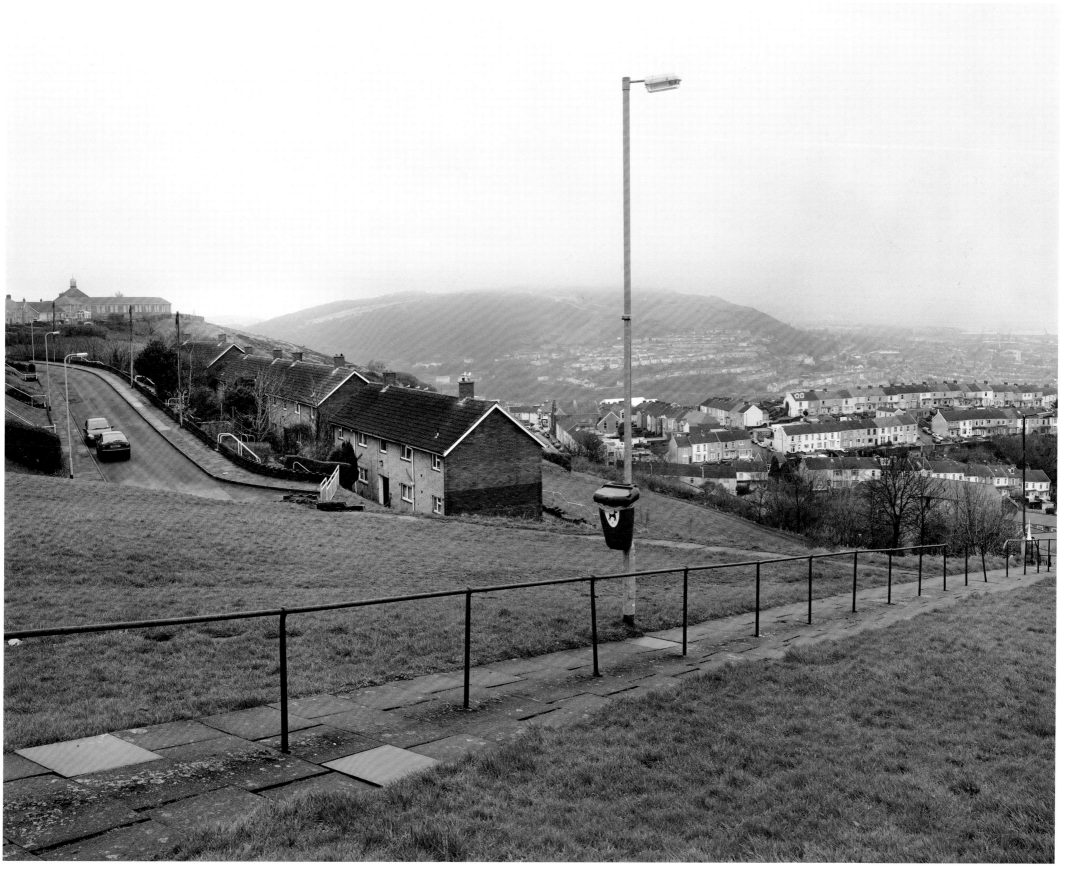

Townhill, Swansea

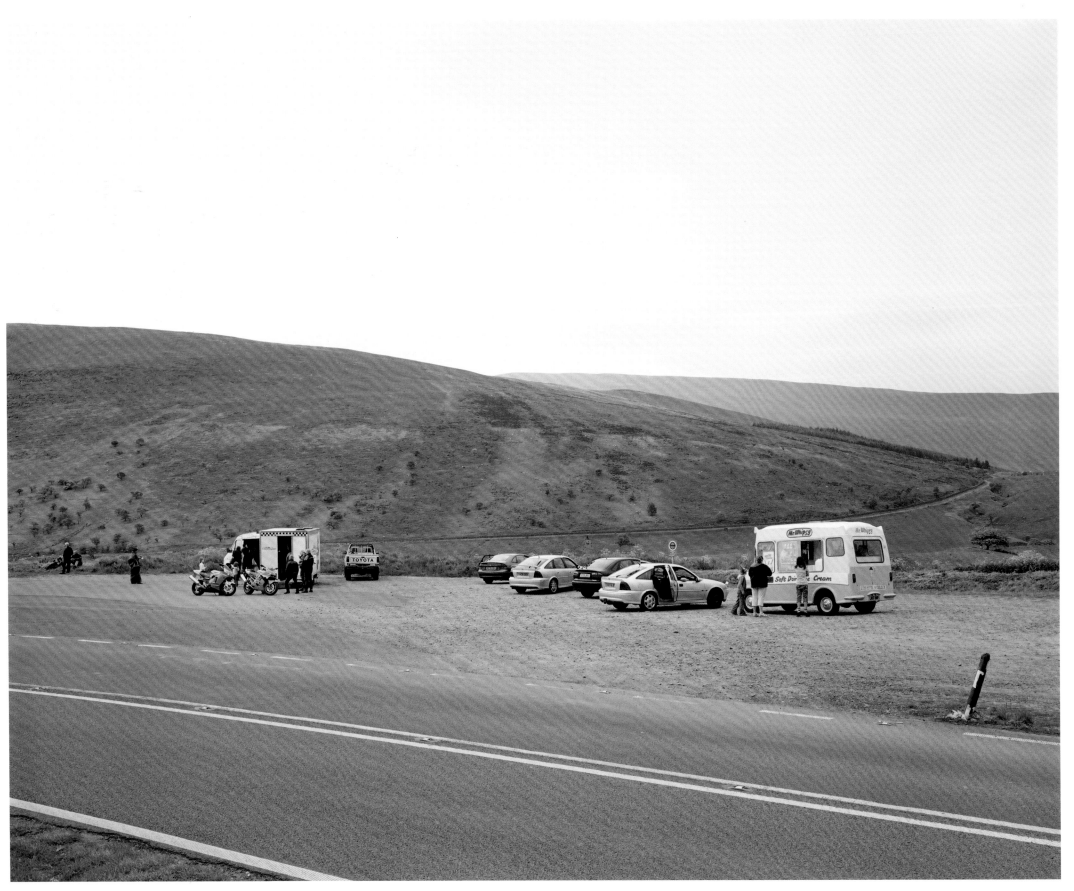

A470, Brecon Beacons National Park, Powys

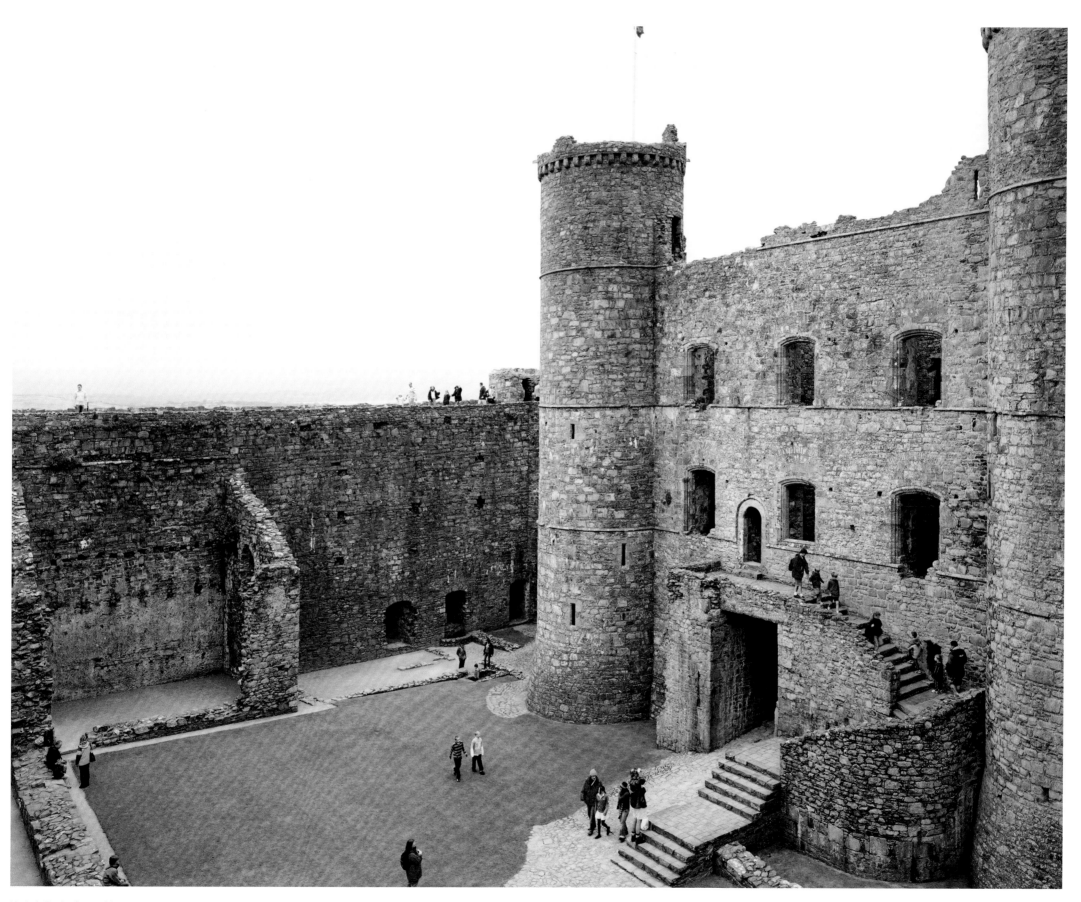

Harlech Castle, Gwynedd

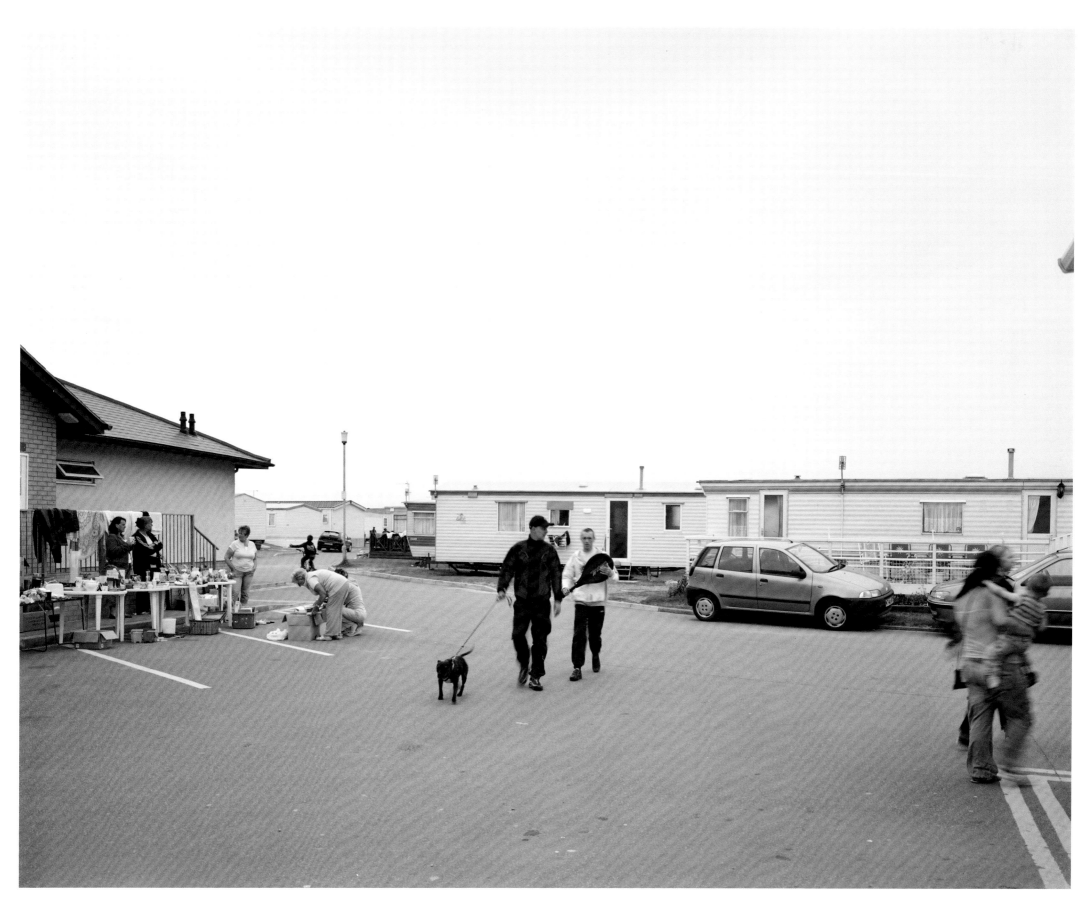

Sunnysands Caravan Park, Gwynedd

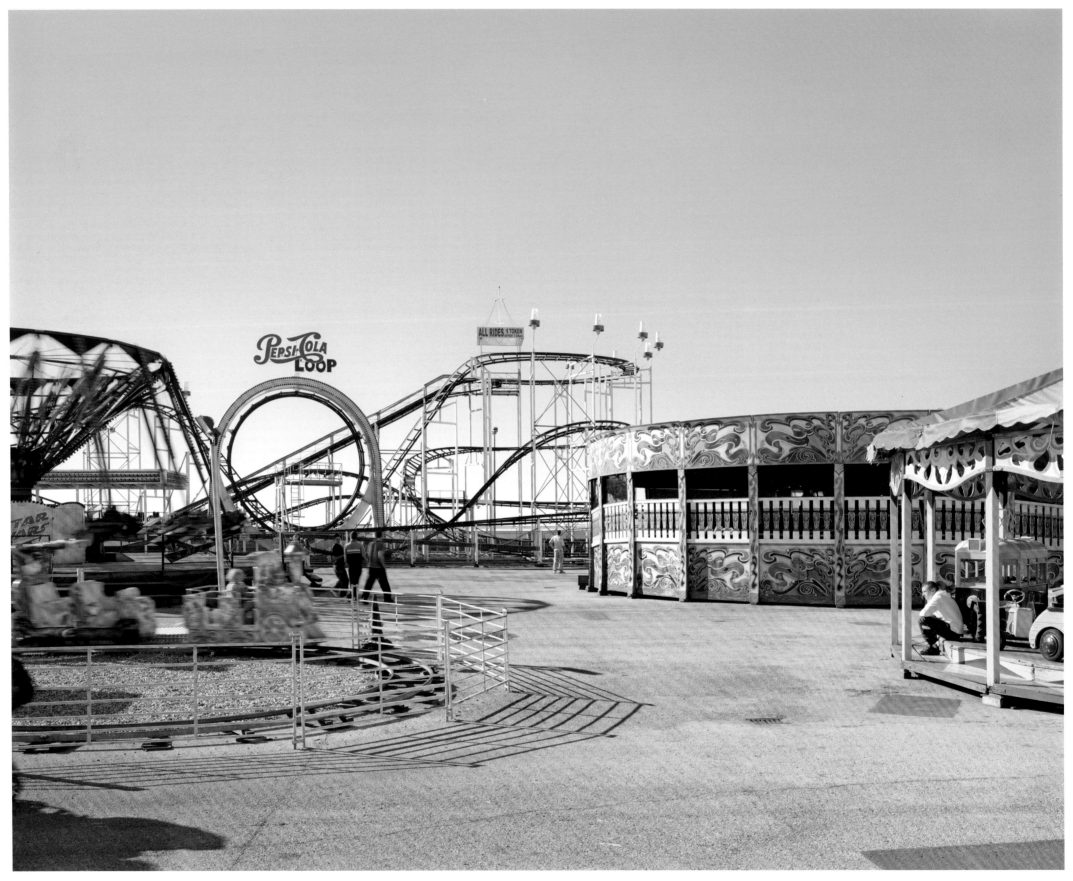

Rhyl, Denbighshire

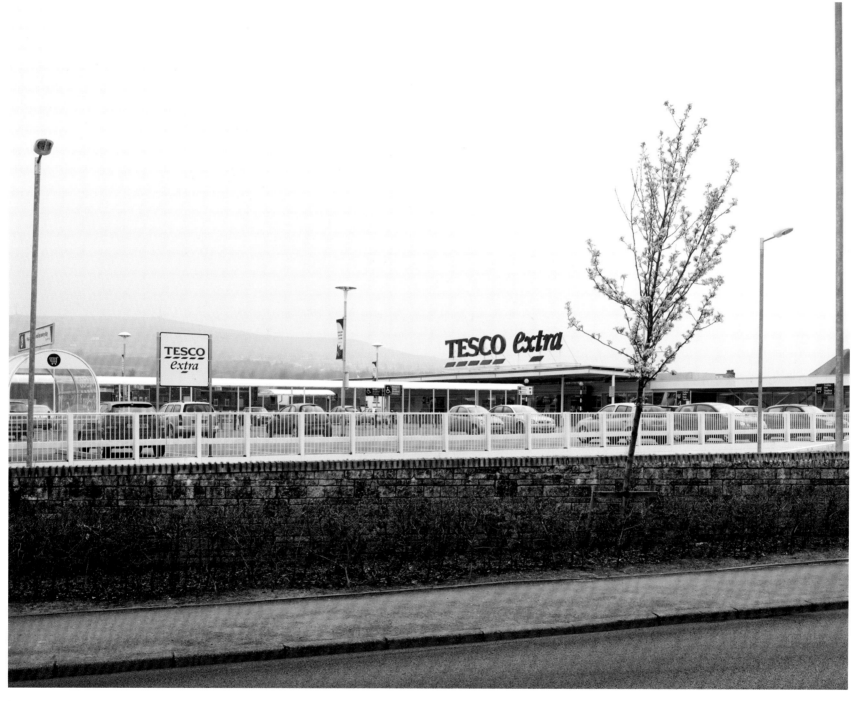

Merthyr Tydfil

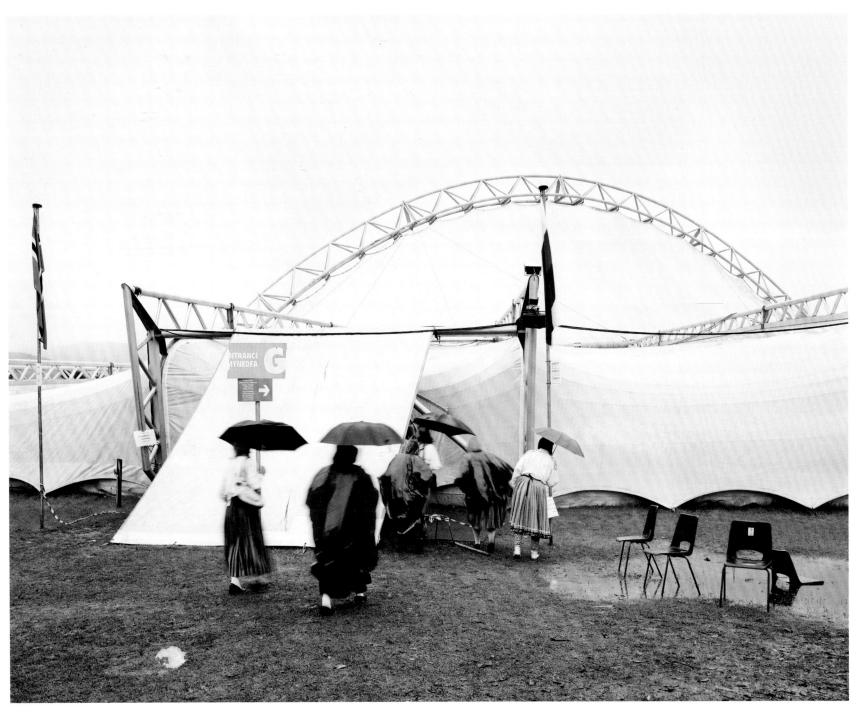

International Eisteddfod, Llangollen, Denbighshire

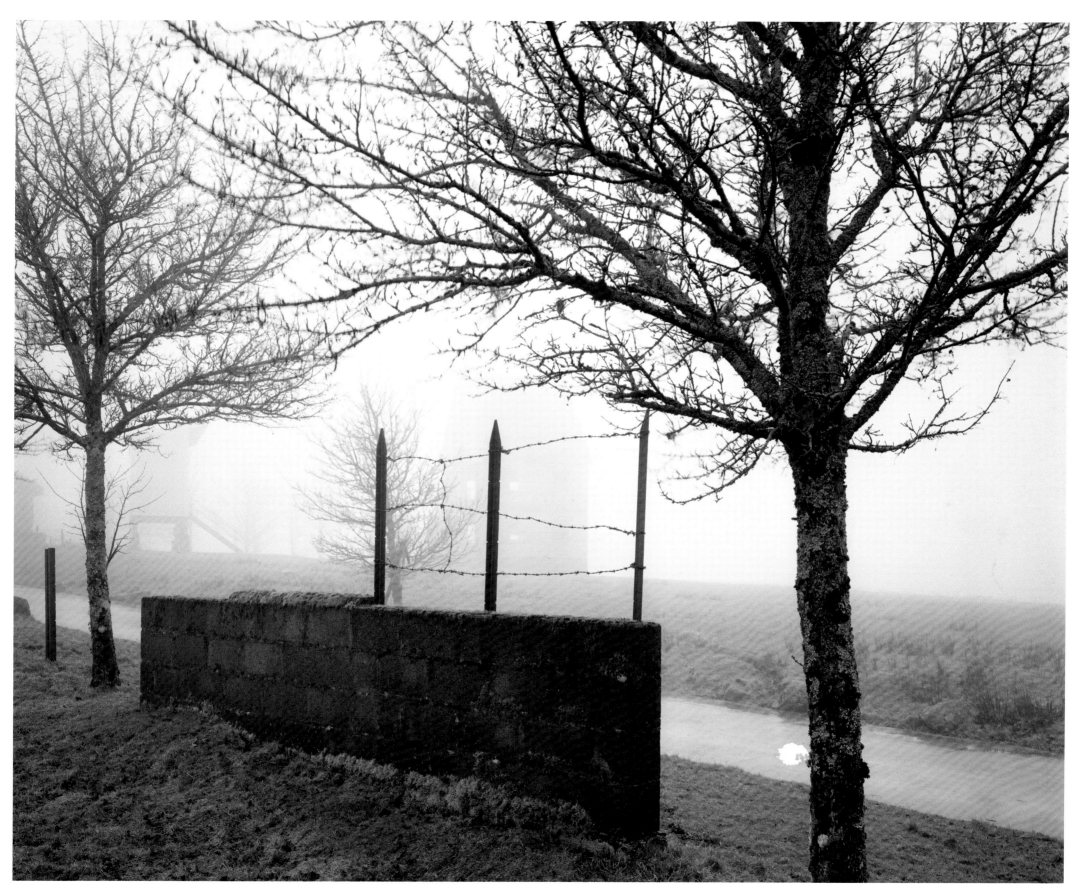

Sennybridge military training camp, Mynedd Eppynt, Powys

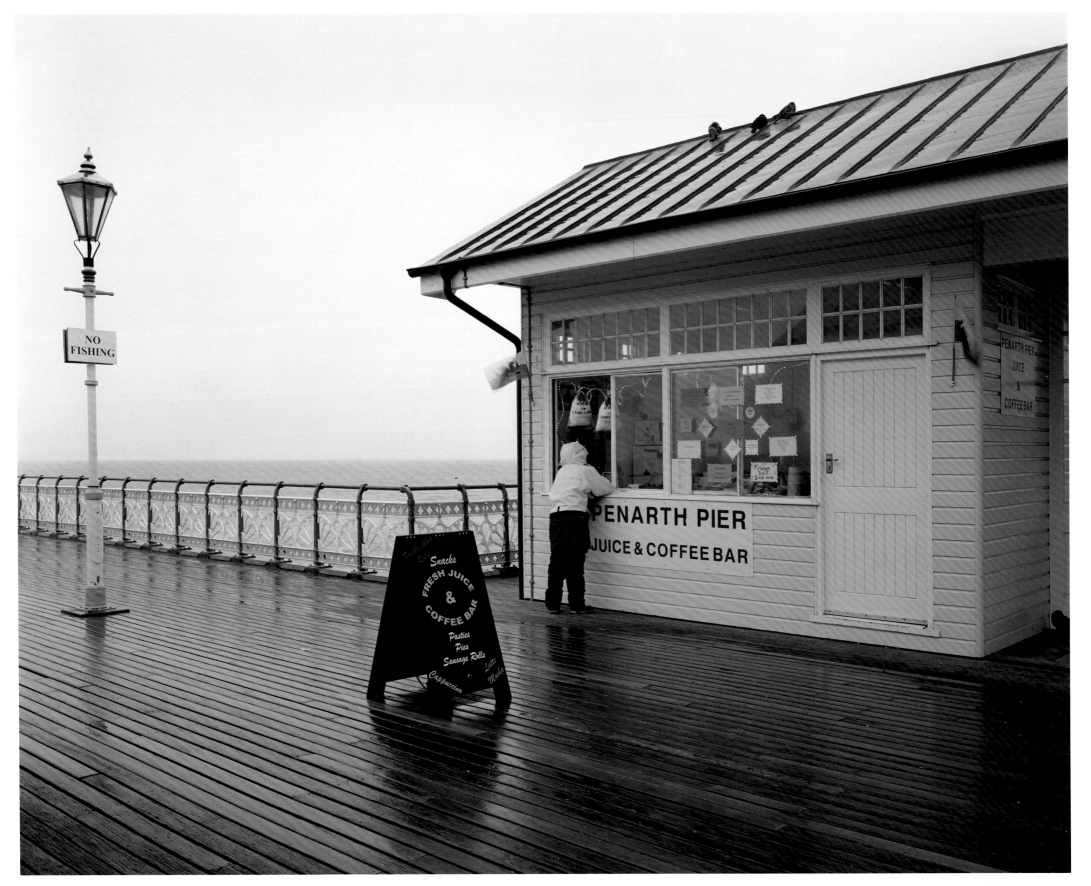

Penarth Pier, Vale of Glamorgan

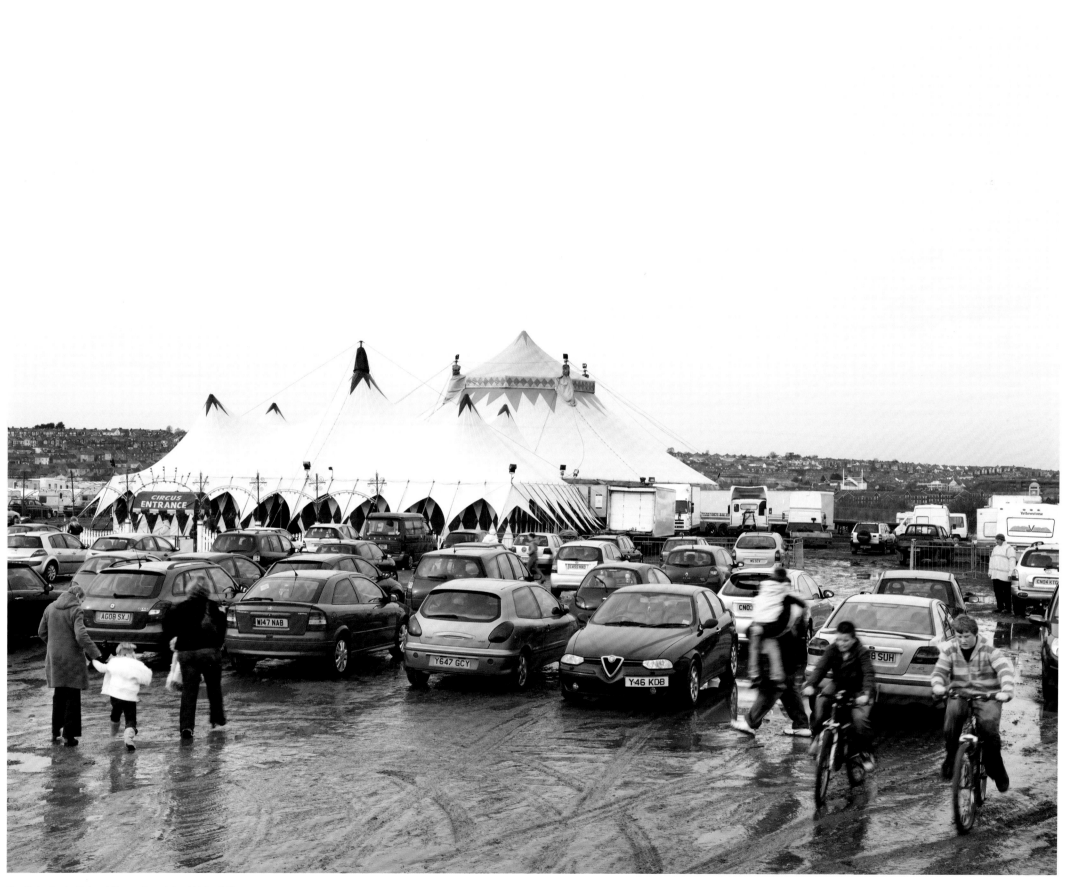

The Netherlands National Circus, Barry Island, Vale of Glamorgan

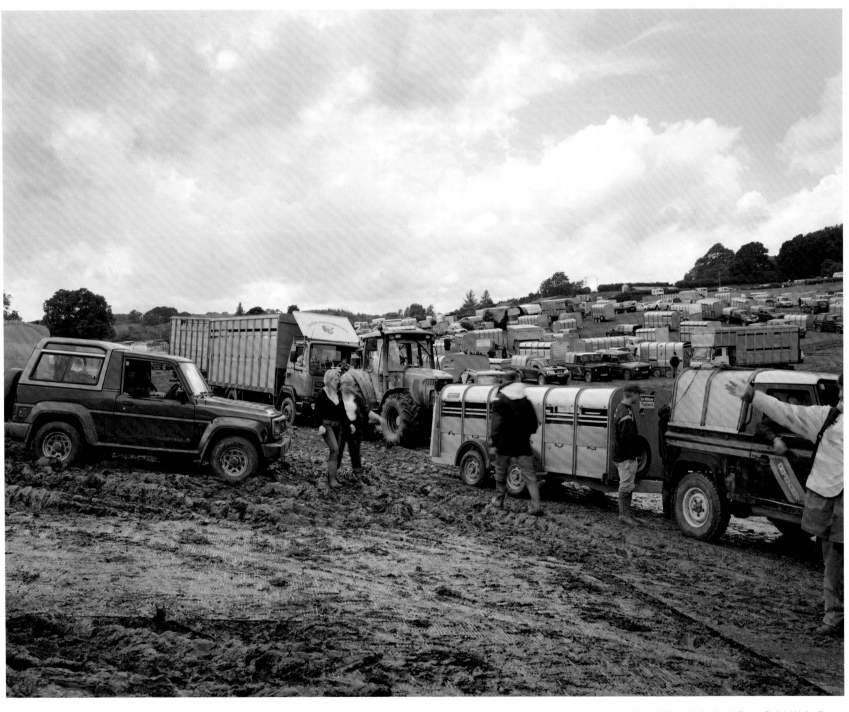

Royal Welsh Agricultural Show, Builth Wells, Powys

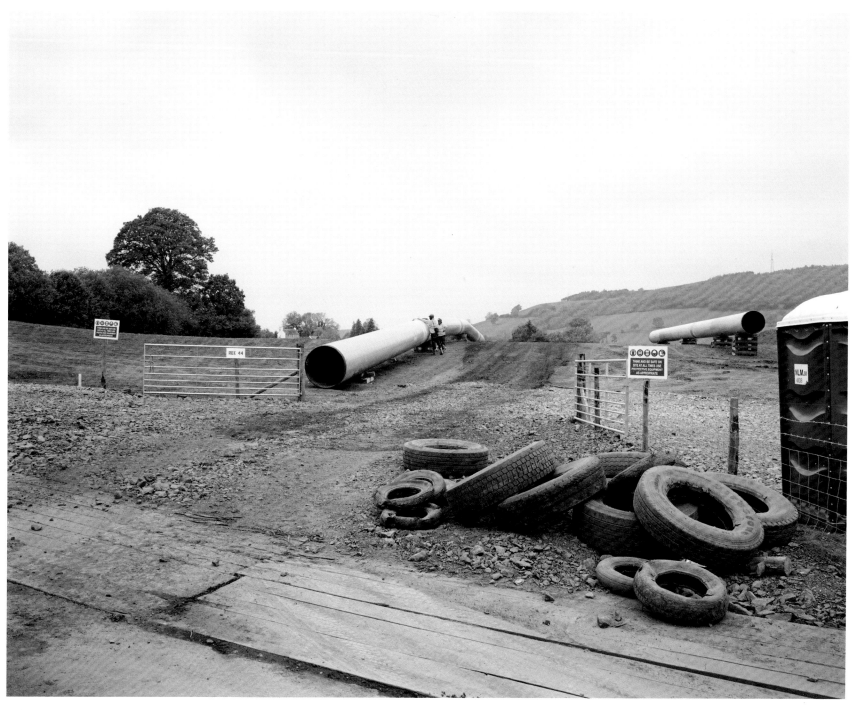

LNG pipline construction, Trecastle, Brecon Beacons National Park, Powys

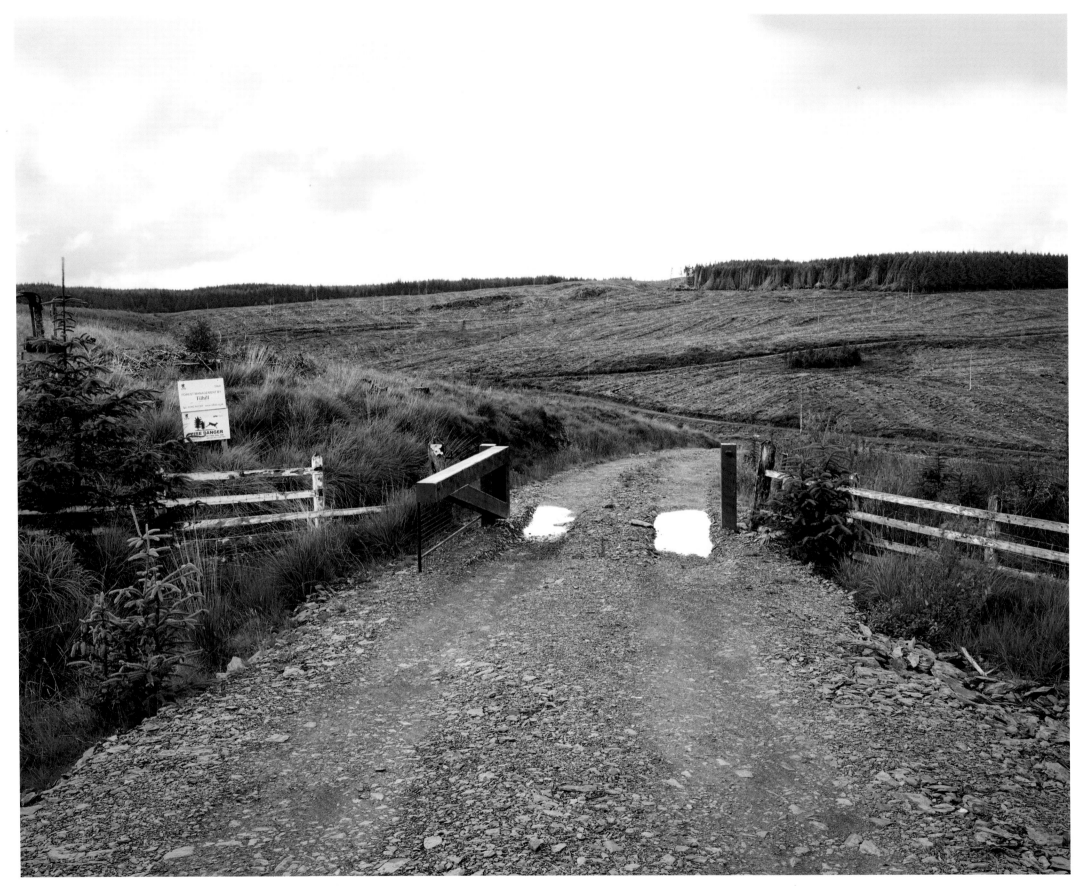

Forestry, Esgair Cloddiad, Powys

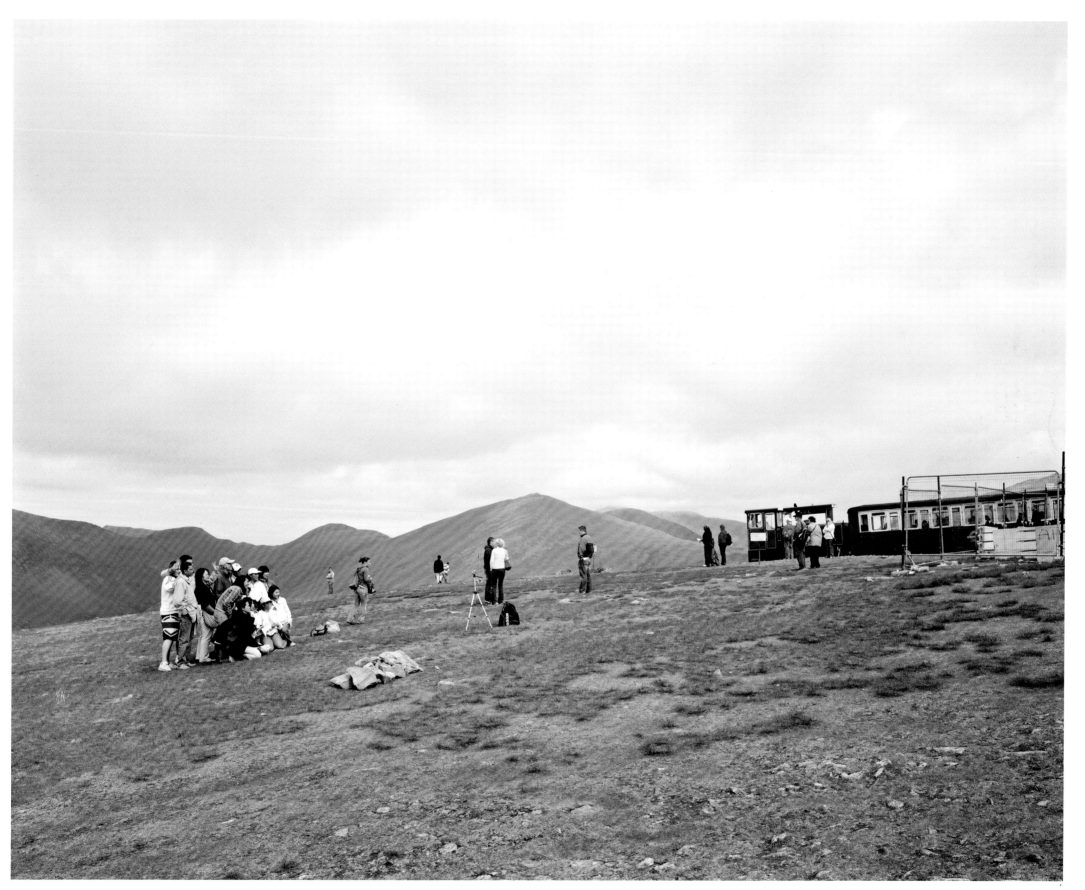

Snowdon, Gwynedd

Harlech, Gwynedd

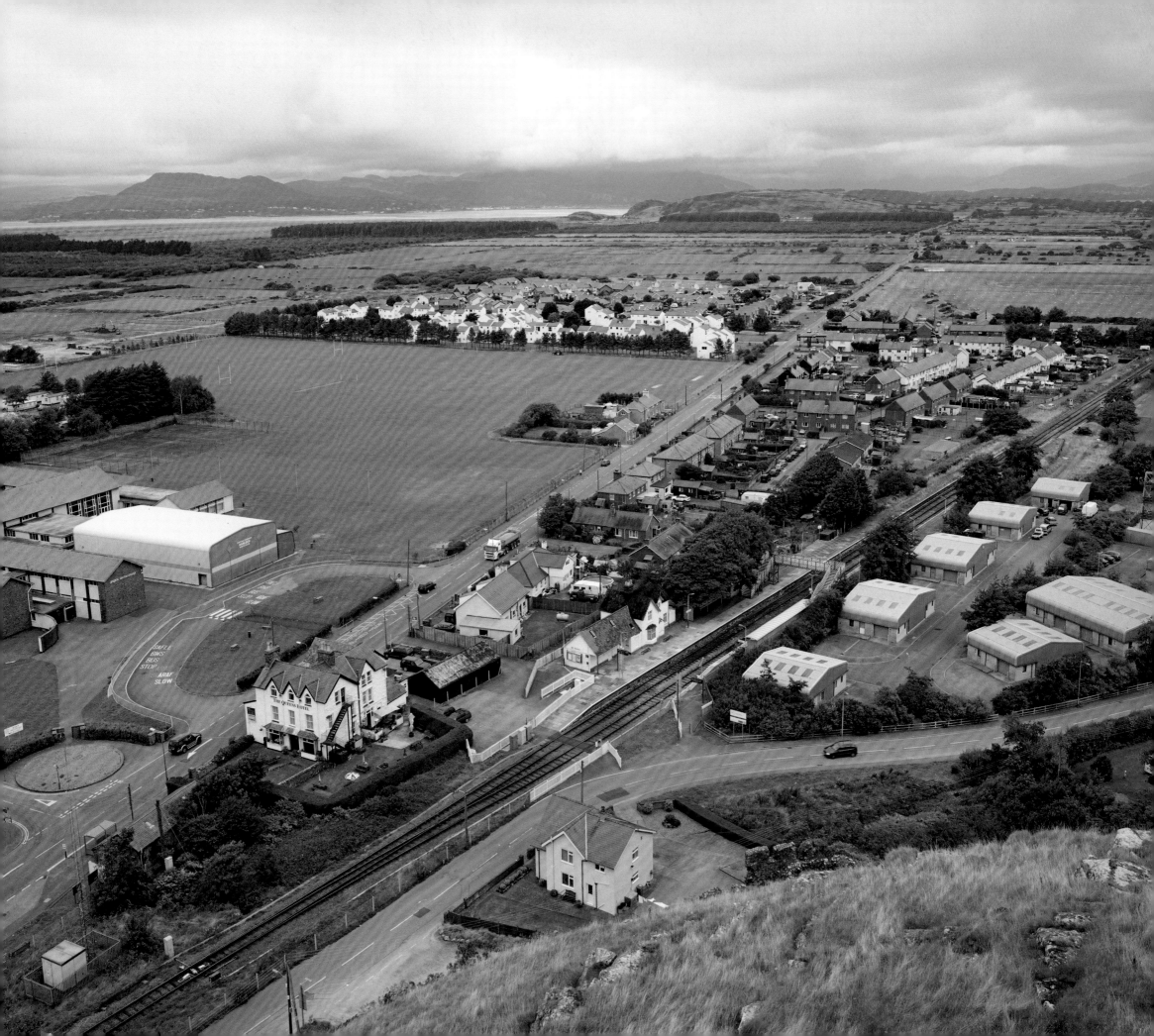

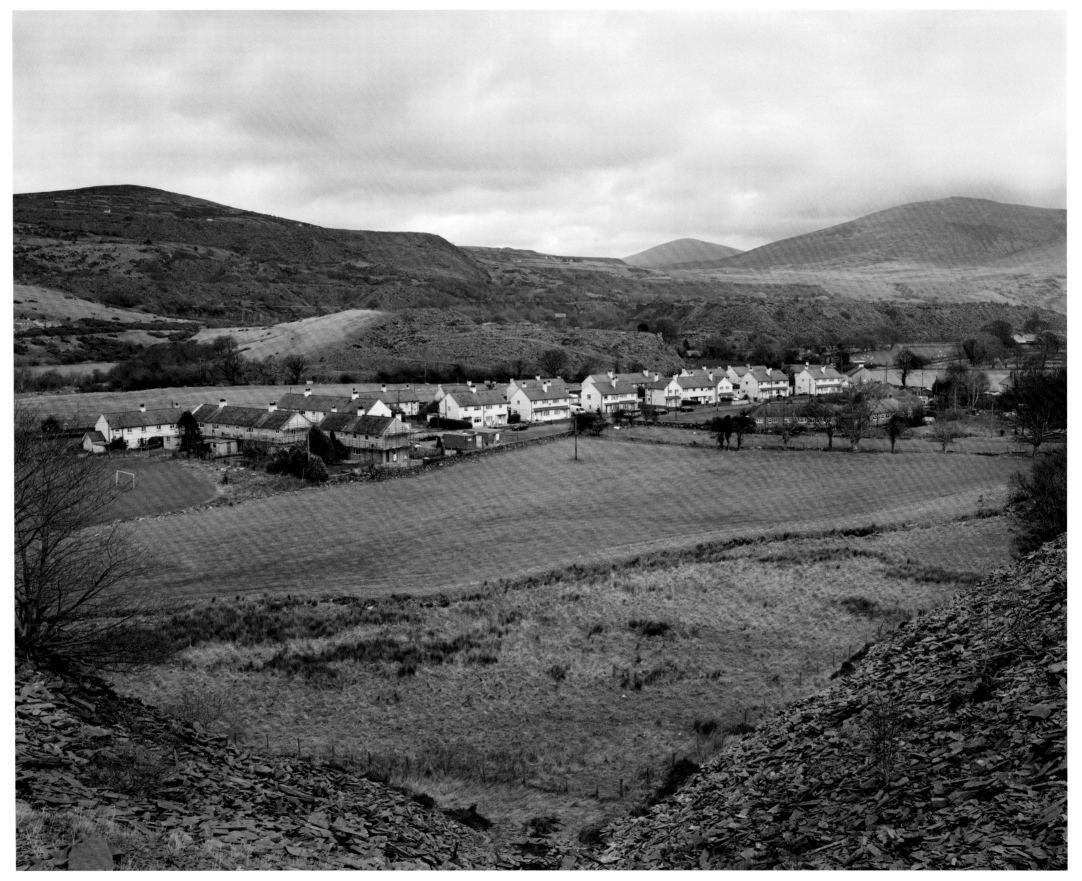

Talysarn, Penygroes, Gwynedd

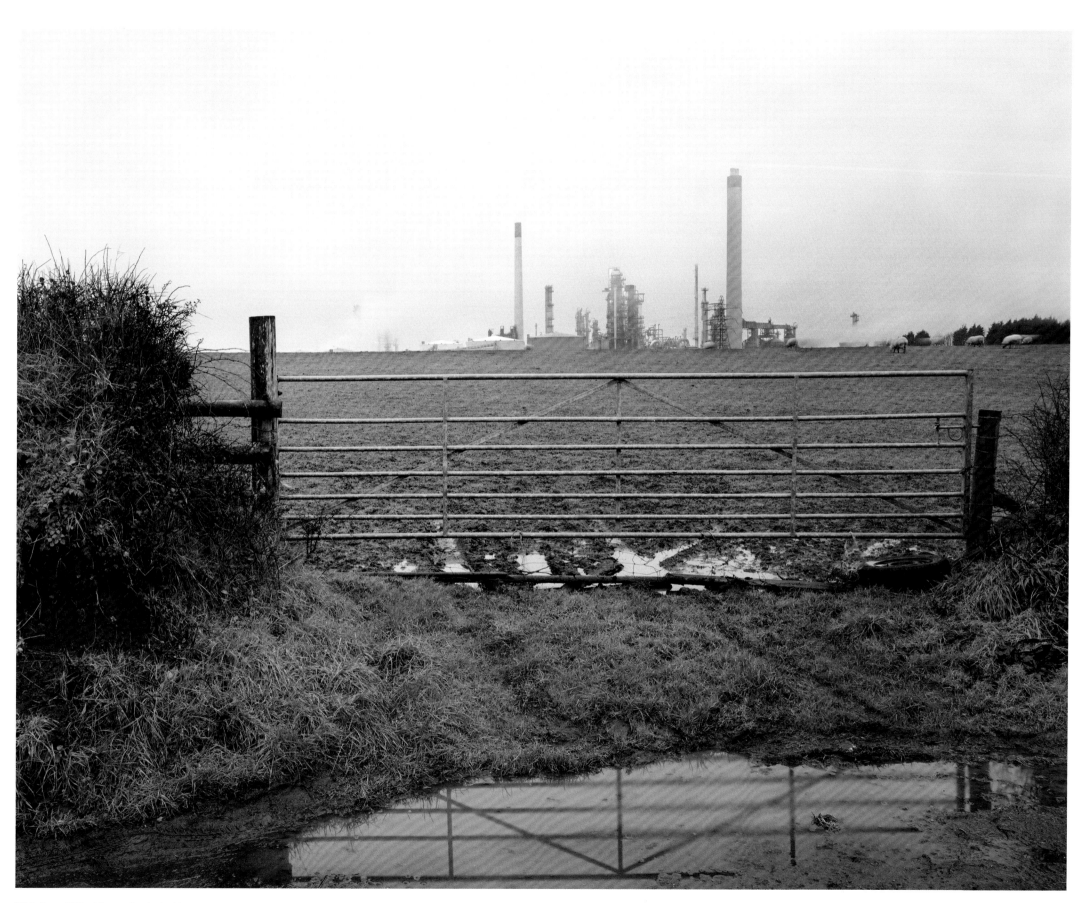

Oil Refinery, Milford Haven, Pembrokeshire

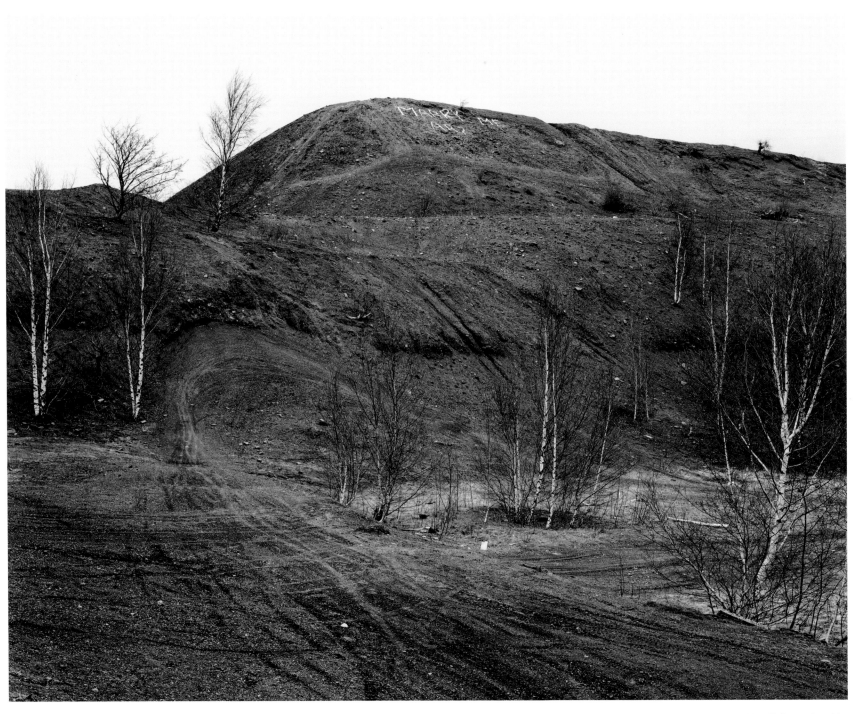

Slagheap, Rhostyllen, Wrexham / Supermarket construction site, Llanelli, Carmarthenshire

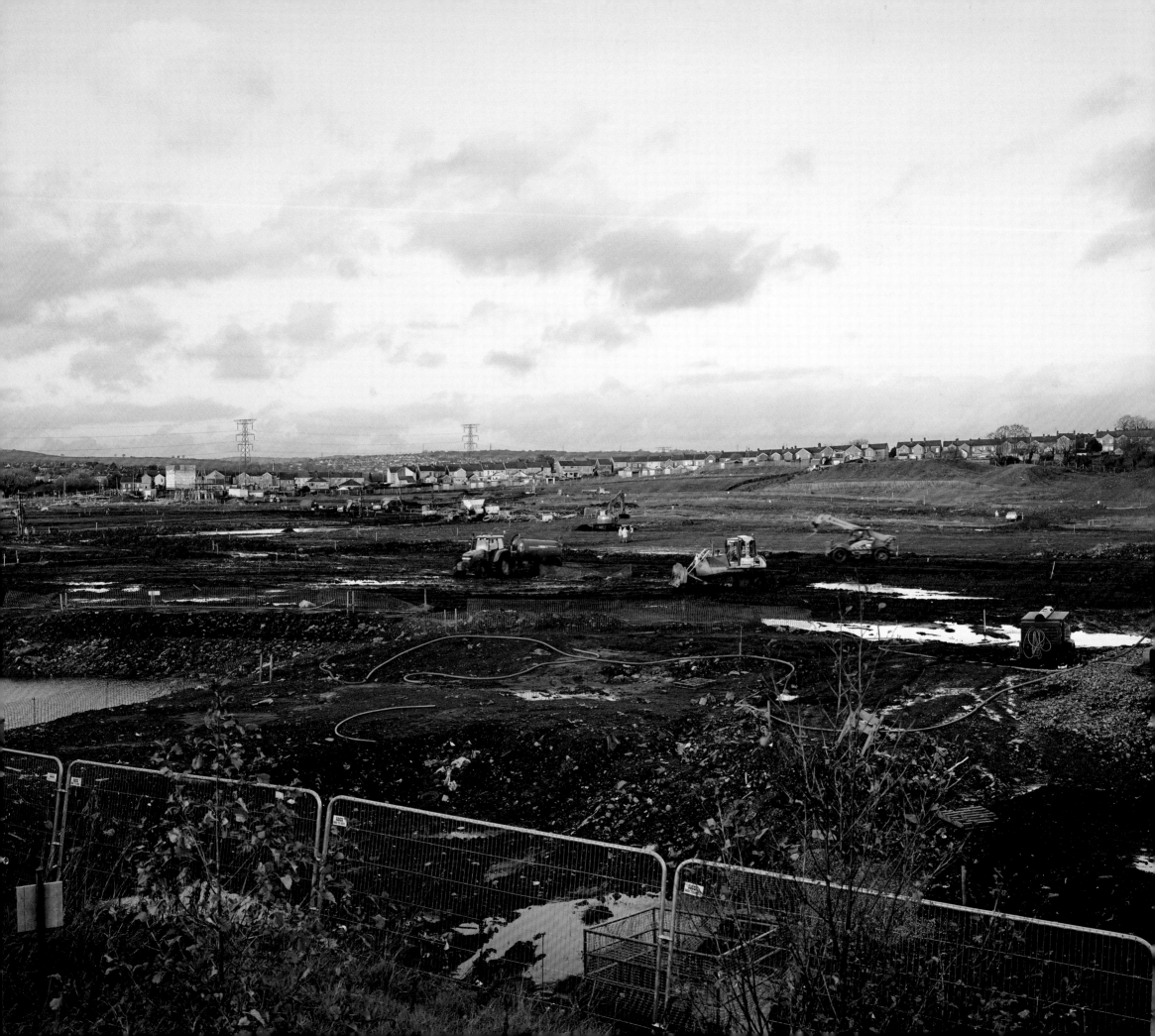

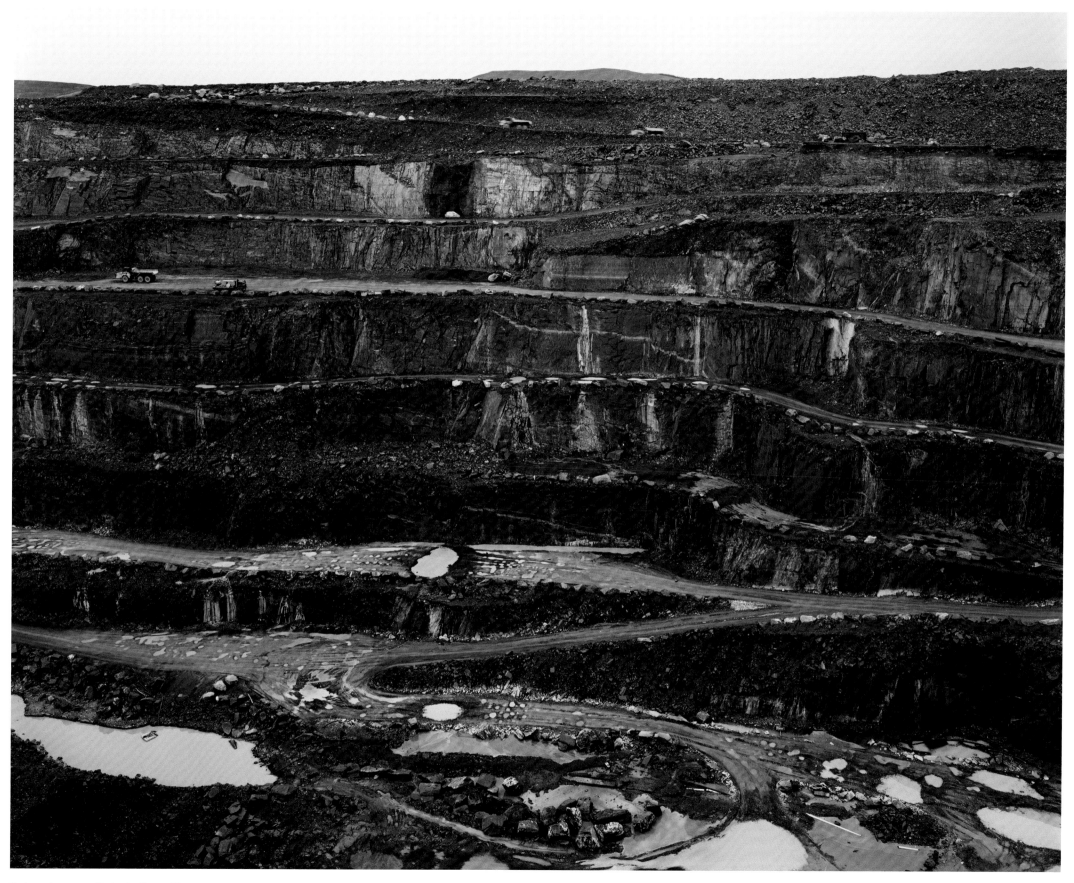

Penbryn slate quarry, Bethesda, Gwynedd

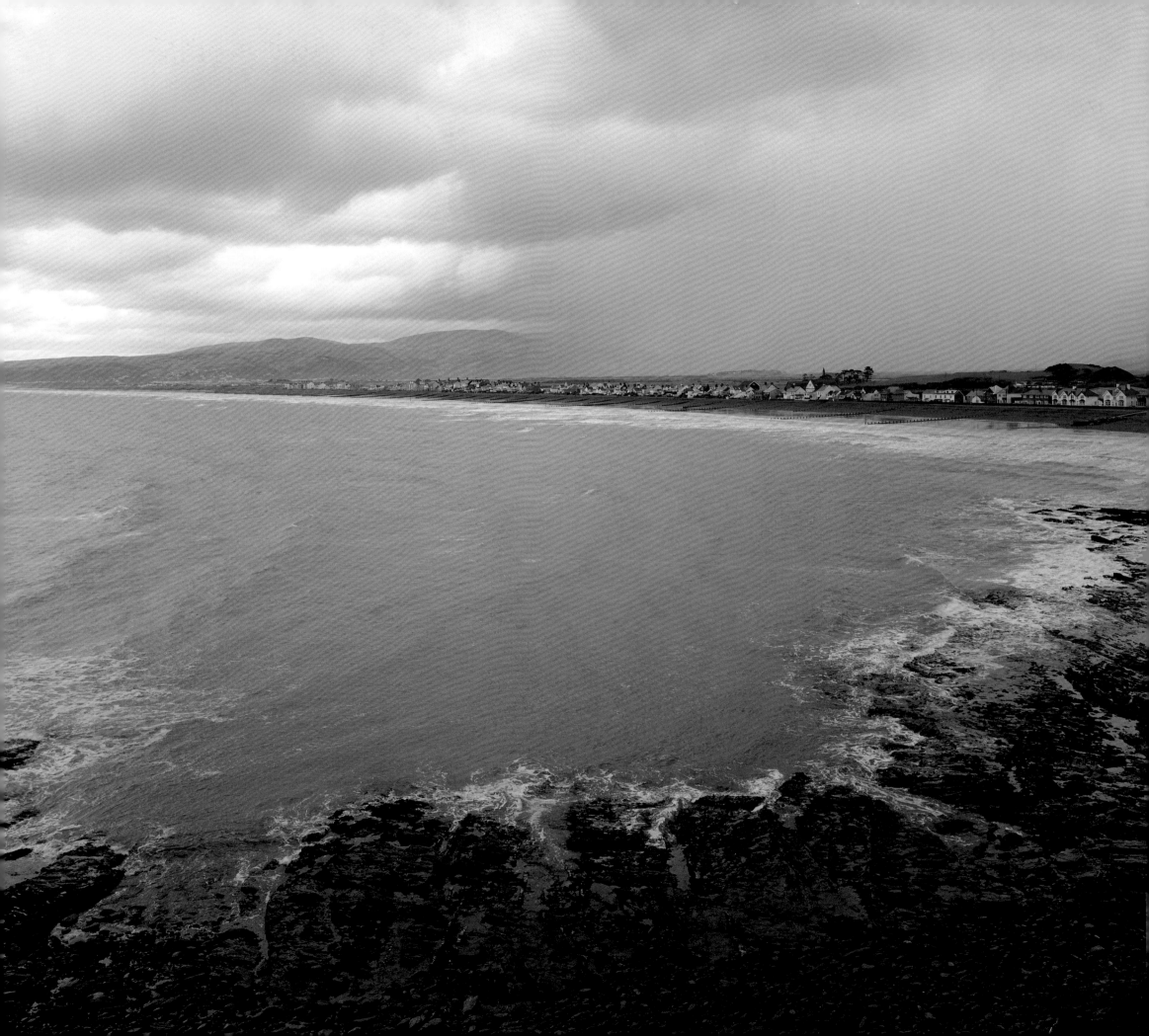

ACKNOWLEDGEMENTS

This project evolved from a conversation with Eve Ropek of Aberystwyth Arts Centre, and her ongoing moral and financial support for the photography, exhibition and this publication have been invaluable.

It was made possible by the further generous support of the Arts Council of Wales, the Welsh Books Council and the Graham Foundation for Advanced Studies in the Fine Arts.

A very deep thanks also to Jim Perrin, Dewi Lewis, Zelda Cheatle, David Drake of Ffotogallery, Michael and Sue Morris, Jasmin Donahaye, Mererid Velios of Celfwaith, Malcolm Drysdale, Rhys Jones of ACT Repro, Hannah Lewis; all the voices of encouragement or bemusement received along the way; those who provided access and companionship; the Pembrokeshire Police for not pressing charges under the Terrorism Act 2000 for photographing a tree; and, as always, Giovannella, Sofia and Arianna for their great help and support.

Published in conjunction with the exhibition *A Landscape of Wales* organised and toured by Aberystwyth Arts Centre, Aberystwyth University.

First published in the United Kingdom in 2010 by
Dewi Lewis Publishing
8 Broomfield Road, Heaton Moor
Stockport SK4 4ND, England

www.dewilewispublishing.com

ISBN: 978-1-904587-89-7

Design: Dewi Lewis Publishing
Print: EBS, Verona, Italy
Printed on Gardamatt 170gsm

The publisher and the author acknowledge the financial support of Aberystwyth Arts Centre, the Arts Council of Wales, the Welsh Books Council, and the Graham Foundation for Advanced Studies in the Fine Arts.

Canolfan y Celfyddydau
Aberystwyth Arts Centre

Cyngor Celfyddydau Cymru
Arts Council of Wales

CYNGOR LLYFRAU CYMRU
WELSH BOOKS COUNCIL